Caroline Bugler

DUTCH PAINTING

MAYFLOWER BOOKS
NEW YORK

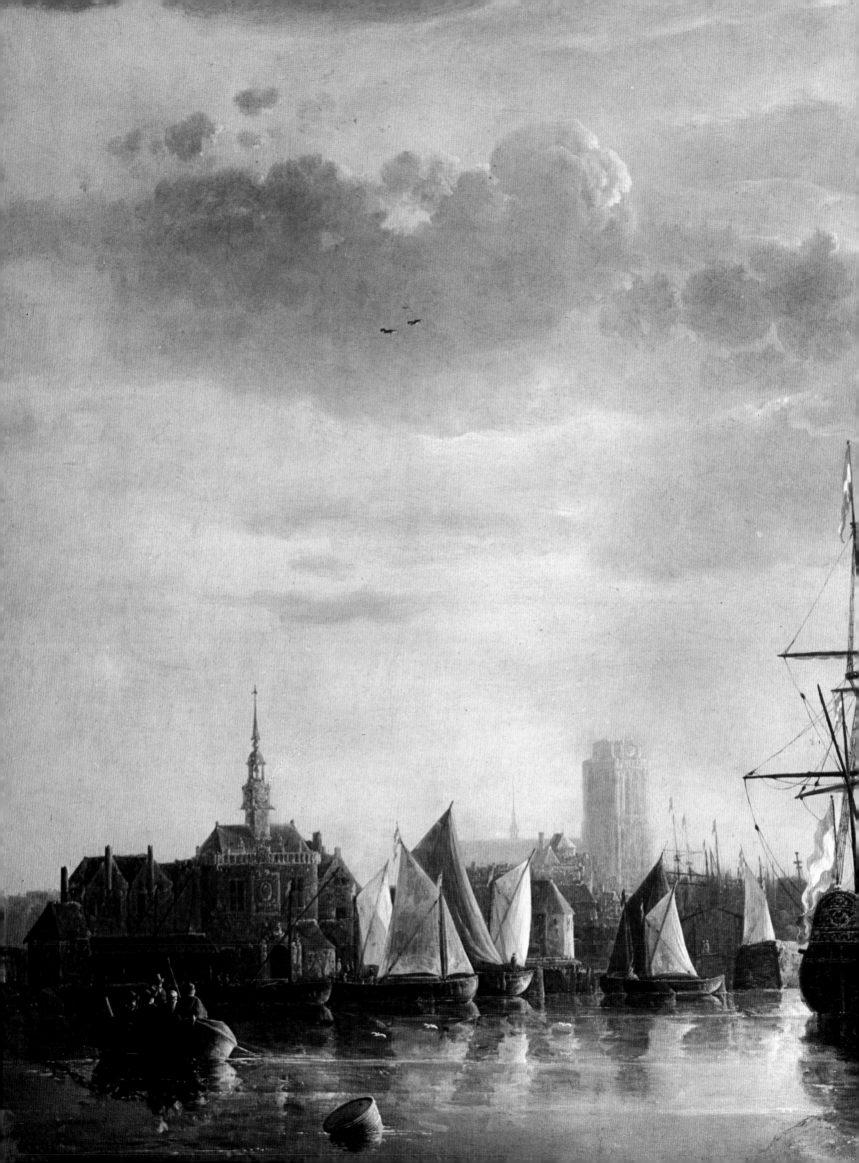

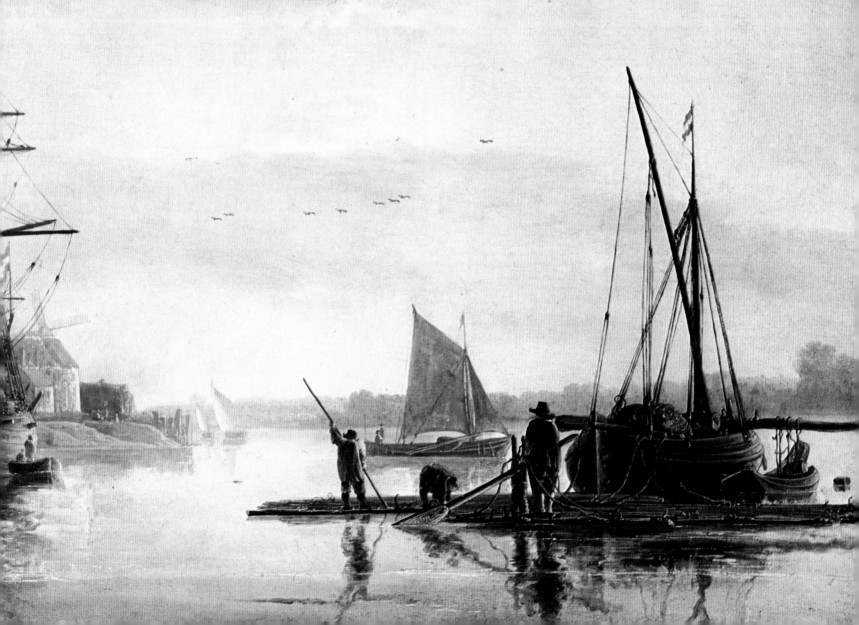

Caroline Bugler

DUTCH PAINTING

IN THE SEVENTEENTH CENTURY

OVERLEAF **Cuyp**: *A View of Dordrecht*, 97·8 × 137·8cm

MAYFLOWER BOOKS, INC.,
575 Lexington Avenue, New York City 10022

© TEXT 1979 Phaidon Press Limited
© DESIGN 1979 Heraclio Fournier, S. A.

The film positives of the illustrations are
the property of Heraclio Fournier, S. A.

Library of Congress Cataloging in Publication Data

BUGLER, CAROLINE.
Dutch seventeenth-century painting.

1. Painting, Dutch. 2. Painting, Modern –
17th-18th centuries – Netherlands. I. Title.
II. Series.
ND646.B77 759.9492 78–24553
ISBN 0–8317–2483–8
ISBN 0–8317–2484–6 pbk.

Printed and bound in Spain by HERACLIO FOURNIER SA, *Vitoria.*
First American edition
Filmset in England by SOUTHERN POSITIVES AND NEGATIVES
(SPAN), *Lingfield, Surrey*

Dutch Painting

THERE IS A PAINTING by Adriaen van Ostade in the Dresden Gemäldegalerie that shows the artist hard at work in his studio; he is painting in a relatively humble garret furnished with all the tools of his profession. Apart from the three-legged easel, a precursor of the modern upright easel, at which the painter is comfortably seated, there are his paints and brushes on the stool beside him, an articulated wooden lay figure, a cast of a head lying under the table in the bottom left hand corner, and a piece of linen hung under the ceiling to protect the painting from dust. Strewn over the floor are engravings or sketches, which the artist has used as source material. The painting on the easel looks like a landscape. Barely visible in the background, an apprentice grinds the colours that his master will use.

Vermeer's *The Artist in his Studio*, sometimes called *An Allegory of Painting*, presents the artist in a more affluent setting. The studio, like Ostade's, is simply an ordinary room in a house, with no special architectural adaptations, such as large windows. It is obvious here that the artist is painting the model in front of him, since we can glimpse over his shoulder the beginnings of her laurel wreath upon the white primed canvas. Vermeer's picture also differs from that of Ostade in its complex symbolism. What we are presented with is not a literal description of the artist in his studio, but a manifesto on the art of painting. The trumpet held by the girl, her laurel wreath, the mask on the table, and the books are carefully placed props in an allegory, and not objects which have been randomly distributed around the room. Similarly, the artist's outfit is closer to being fancy dress than working clothes. The model standing by the window probably represents the Muse of History, while her sister Muses of Drama and Literature are evoked by the presence of the books and mask. When read together, these items can be seen to add up to a glorification of the art of painting, which enshrines all three subjects, and, in particular, to a glorification of Dutch painting, since a map of Holland is conspicuous on the back wall.

What do these two, quite different paintings tell us about art in seventeenth-century Holland? They point to a variety not only of technique and subject matter, but also of social status among artists. Painting was an art practised by both the middle classes and those who were less rich. It was generally carried out in the artist's own home, often with the help of an apprentice, who may have had a studio in an adjoining room. There was nothing romantic about the profession of painter; it was a trade which, like any other, required a training. This was usually given by apprenticeship. The apprentice would begin by carrying out the menial tasks in the master's studio, such as stretching the canvas, grinding pigments, and sometimes painting in the drapery on the master's paintings. The instruction he received in return consisted largely of copying works either by the master, or from his personal collection, drawing from the life, and eventually painting the same subject as his teacher.

When a pupil was sufficiently competent in these spheres, he would leave and set up his own studio. Every painter was obliged to join the artists' Guild of St Luke in the town where he lived, if he hoped to sell his work. Like any other guild, the Guild of St Luke acted both as a check on the quality of what was produced, and as a means of protecting livelihood. Apart from commissions, sales outlets could be found at fairs, auctions, or through dealers. Fixed contracts, whereby a painter worked exclusively for a dealer in return for a stable income, were not unknown.

Until the Reformation, the church had been a great patron to artists, but, as any glance at the paintings of bare church interiors shows, this particular source dried up with the rise of Protestantism, and its attendant iconoclasm. Nor did the state fill the gap left in official patronage. With the exception of the decoration of the newly built town hall in Amsterdam, and the Huis ten Bos, a dwelling designed for the Prince of Orange, in The Hague, there were few important state commissions. The small court at The Hague tended to patronize only portraitists. Most painting was aimed at the open market, but the art market was overcrowded. The sheer number of painters vying with each other to make a living meant that the profession was often financially precarious, and many artists had to seek part of their income from another source. Vermeer, for instance, was an art dealer as well as painter. Steen was a tavern owner, Cuyp a land-owner, and Hobbema a wine gauger.

The number of pictures in circulation, and the generally

Adriaen van Ostade: *The Painter's Studio*, 35·5 × 40cm, 1663

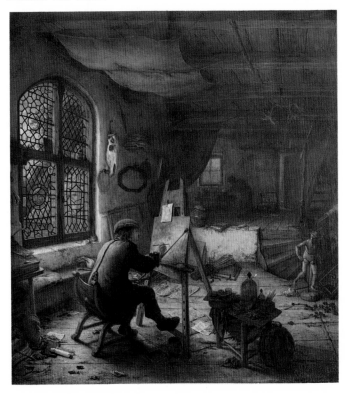

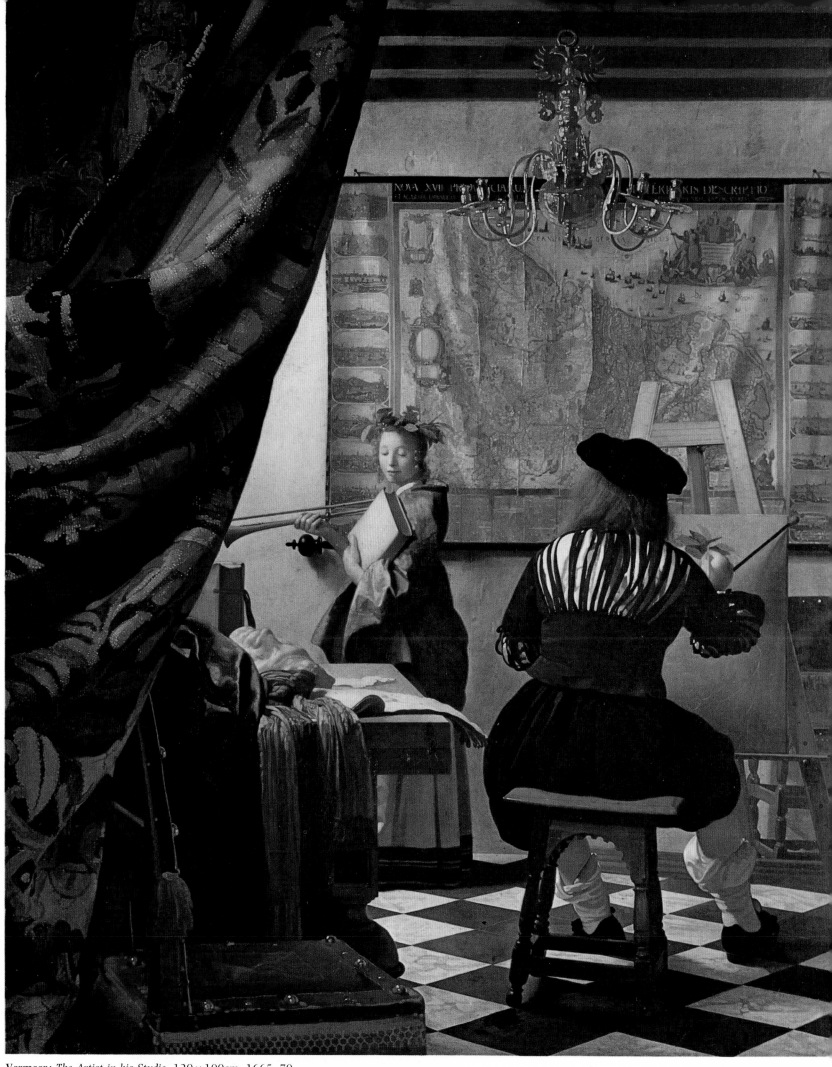

Vermeer: *The Artist in his Studio*, 120 × 100cm, 1665–70

high regard for art held by the Dutch astonished foreign visitors to the country. The Englishman, Peter Mundy, who travelled to Amsterdam in 1640 commented:

> As for the art off Painting and the affection off the people to Pictures, I thincke none other goe beyond them, there having bin in this country many excellent men in that Facullty, some att present as Rimbrantt, etcs. All in general striving to adorne their houses, especially the outer or street roome, with costly peeces. Butchers and Bakers not much inferior in their shoppes which are Fairely sett forth, yea many tymes, Blacksmiths, Coblers etc. will have some picture or other by their Forge and in their stalle. Such is the general Notion enclination and delight that these country Natives have to paintings.

Amsterdam was the centre of the art market, not just for Holland, but for the whole of Northern Europe, and in the mid-seventeenth century there are said to have been more than 300 painters working in the city. Yet despite the artistic dominance of the capital, several other towns in the United Provinces, such as Utrecht, Haarlem, Leiden, and Delft, and, to a lesser extent, The Hague and Rotterdam, flourished as centres in their own right, often promoting an individual style of painting. It was, for example, in Haarlem not Amsterdam that the first steps were made in the late sixteenth century towards reviving the art of painting which had suffered everywhere in Holland during the religious and political turmoil earlier in the century. The Haarlem Academy

Honthorst: *The Nativity,* 138 × 204cm, 1620

Gerrit van Honthorst was one of the generation of Dutch painters who spent some time in Italy early in the century, and who, on their return to Holland, imported a style based on the work of the Italian painter, Caravaggio. The essence of Caravaggio was his dramatic use of chiaroscuro, and his pronounced juxtaposition of areas of light and dark. Honthorst learnt a great deal from this treatment, and became so adept at painting artificially lit scenes that he earned the nickname 'Gerardo della Notte', or 'Gerard of the Night'. This work was finished just before he left Italy, in about 1620. Typical of Honthorst is the way in which the angel on the left is seen in profile, his features lit by the light emanating from the Christ child. The composition is pleasingly simple, with all the figures united, spatially and emotionally, in their adoration of the infant. Significantly, there is a space left in the circle of those who surround Christ for the spectator.

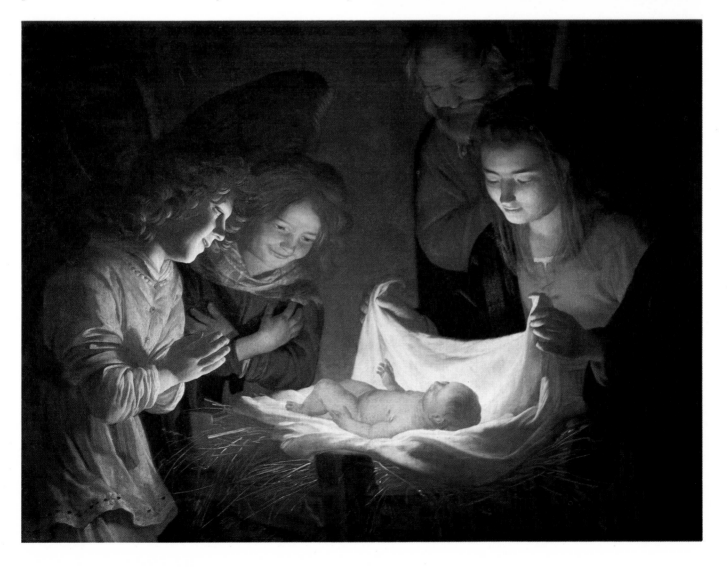

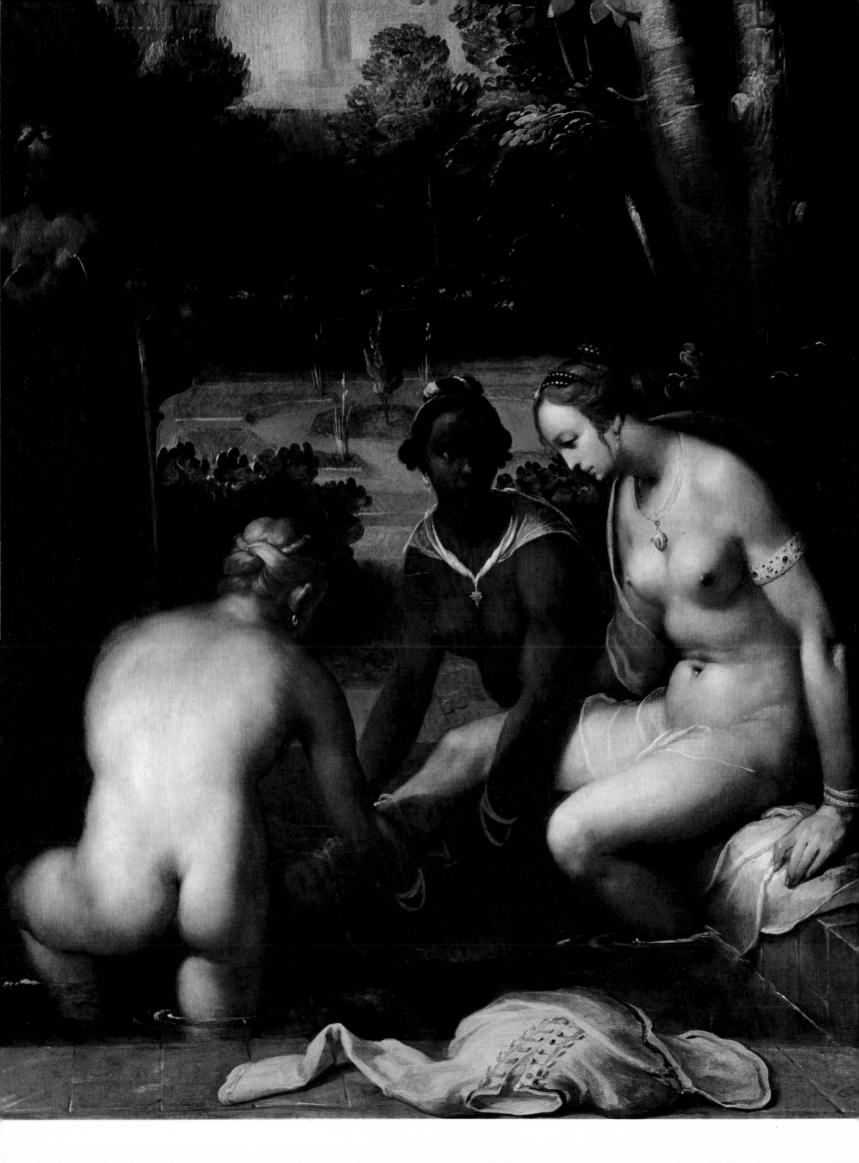

was founded in the 1580s by Carel van Mander, Heinrich Goltzius, and Cornelis van Haarlem, and was most effective in developing the international Mannerist style in Holland. Cornelis van Haarlem's *Bath of Bathsheba* is an excellent example of this rather Italianate way of painting. Utrecht at the turn of the century also boasted a large number of artists, among them Gerard Honthorst and Dirck van Baburen, both of whom had studied in Italy, and subsequently imported to their native land a method of painting based on the Italian artist, Caravaggio. One can certainly distinguish leading characteristics in the pictures of each town: there is never any danger of confusing the work of an Utrecht painter like Honthorst with that of a Leiden artist, such as Gerard Dou. But it should be remembered that artists moved freely from one town to another, and that there was a constant interchange of style and ideas which could blur regional differences in painting.

Netherlandish patrons in the early seventeenth century tended to favour anecdotal genre scenes, portraits, landscapes and still lifes, rather than religious or history paintings. Large canvases of the type produced by Rubens in Flanders, depicting scenes from mythology or history, would have looked out of place in a Dutch burgher's modest home.

They were also out of tune with a mentality which demanded of painting only what the eye could see, subjects which were tangible rather than abstract. Yet it would be misleading to say that there was no religious painting at all. Early in the century the Utrecht painters, Honthorst and Terbruggen, specialized in religious works, and Utrecht, as a predominantly Catholic town, would have provided a naturally favourable atmosphere for the depiction of such themes. Most artists could count at least a few religious works in their oeuvre, and the Catholic Jan Steen, better known for his bawdy tavern scenes, painted over sixty religious pictures.

Rembrandt is said to have executed over 160 oil paintings on religious themes, as well as countless drawings and etchings. There is not much information on how many of his biblical works were commissioned, but it seems likely that there was little public demand for the paintings, although the etchings, which were cheaper and smaller in size, sold well. Rembrandt was drawn to these subjects for their intrinsic interest, not for hope of financial gain. His preferences and interpretations of biblical episodes was also idiosyncratic: the keynote of so many of his pictures is the reaction of an individual to an event, rather than the crowd scenes beloved of Baroque art. This idea is central to

Rembrandt: *The Bath of Bathsheba*, 57 × 76cm, 1643

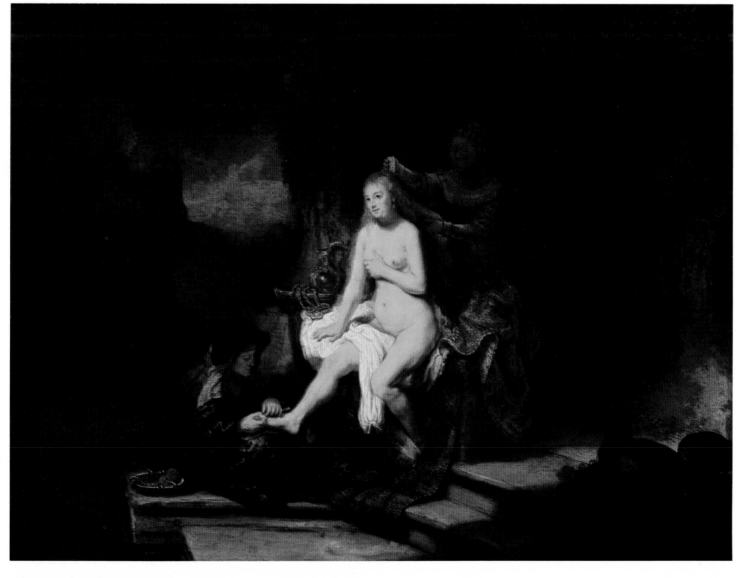

OPPOSITE **van Haarlem**: *The Bath of Bathsheba*, 77·4 × 64cm, c.1595

Jeremiah Lamenting the Destruction of Jerusalem, where the minuteness of handling and the finely wrought detail of the artist's Leiden period is combined with a strong emphasis on chiaroscuro. It is the use of light and shade, together with the sensitive observation of expression, which creates the mood of despondency. There is no extravagant Mannerist gesture but a convincing evocation of weariness and loss in the prophet's pose. He is pensive, unaware of his audience. This feeling of self absorption is carried over into the Louvre painting of *The Bath of Bathsheba*, painted in 1654. Bathsheba grasps the letter from David in her right hand and gazes absently at the handmaid washing her feet. Rembrandt's mastery of expression conveys the complexity of her innermost thoughts. A comparison of this picture with Cornelis van Haarlem's treatment of the same theme shows how far removed Rembrandt was from the tradition of history and biblical painting represented by the previous generation of Haarlem Mannerists. There is a world of difference between the elongated, elegant limbs of the latter painting and Rembrandt's female nude. Rembrandt made constant studies from the life, observing the particularities of each model, and this sense of uniqueness rather than of generality is found in all his figure painting. The model here was probably Hendrickje Stoffels, the maidservant who entered Rembrandt's household on the death of his wife

Rembrandt: *The Descent from the Cross*, 93 × 68cm, *c*.1633

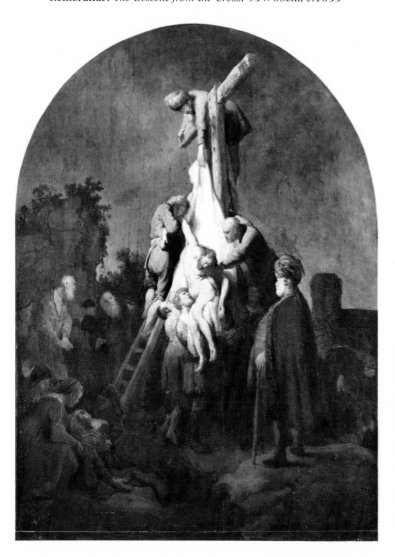

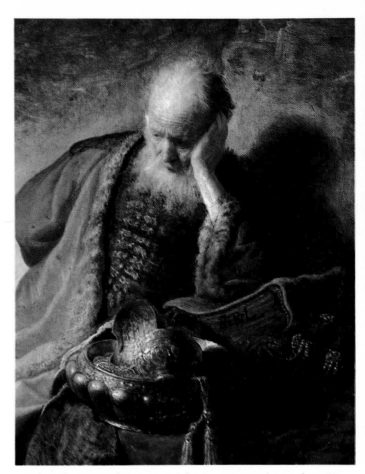

Rembrandt: *Jeremiah Lamenting the Destruction of Jerusalem*, 58 × 46cm, 1630

Saskia, and who eventually became his companion and mistress. Rembrandt has not altered her body, or moulded it to any classical precept.

Rembrandt's anti-classicism could be both shocking and effective in its directness, and the scene from the Passion series reproduced here is an excellent example. The Passion series was actually commissioned by the Stadholder of the Netherlands, Prince Frederick Henry of Orange, in the 1630s. It is interesting that Rembrandt should have looked to the most eminent living exponent of religious painting, Rubens, in determining the composition of this work. Perhaps it was in deference to the taste of the patron, who had a distinct penchant for Flemish painting. Rembrandt had probably seen an engraved version of Rubens' *Descent from the Cross*,

Opposite **Rembrandt:** *The Bath of Bathsheba*, 142 × 142cm, 1654

This canvas does not represent Rembrandt's first attempt at the theme, since the Bathsheba painting in the Metropolitan Museum of Art dates from some ten years before. In the earlier work Bathsheba is shown with two servants. Her surroundings are clearly depicted, and we can see that she is actually sitting on a flight of steps leading down to the river. This version is based on the earlier one, but detail has been suppressed in favour of simplicity, and the figure of Bathsheba completely dominates the composition. Although no preliminary sketches are known, it has been suggested that Rembrandt may have derived the pose of Bathsheba from engravings after Roman antique reliefs. If this is the case, it provides an interesting example of Rembrandt's selectiveness in borrowing, for Bathsheba's physiognomy is very unclassical, and her facial expression completely at variance with the bland serenity of the classical prototype.

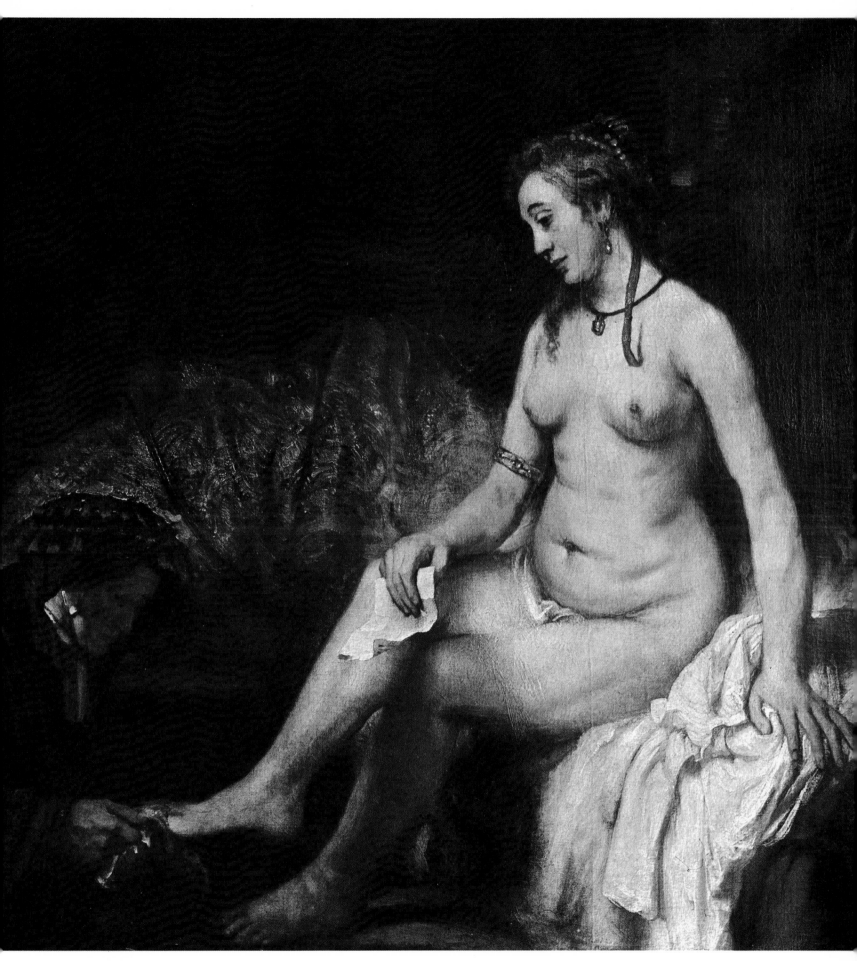

then in Antwerp, for his own work corresponds closely with that painting, but in reverse. Yet where Rubens' Christ is graceful and heroic, his body taut and muscular, Rembrandt's Christ sags ignominiously.

The figure of Christ is a pivotal point in Rembrandt's religious paintings, especially in his later years, when he turned to the New Testament as a source of ideas. The Louvre *Christ at Emmaus* painted in 1648 is quite different in mood to the violently anti-classical paintings of the 1630s. The stability of the composition is remarkable: the architectural background, the arch, and the frontal presentation of the table lend an air of calm serenity to the scene of Christ

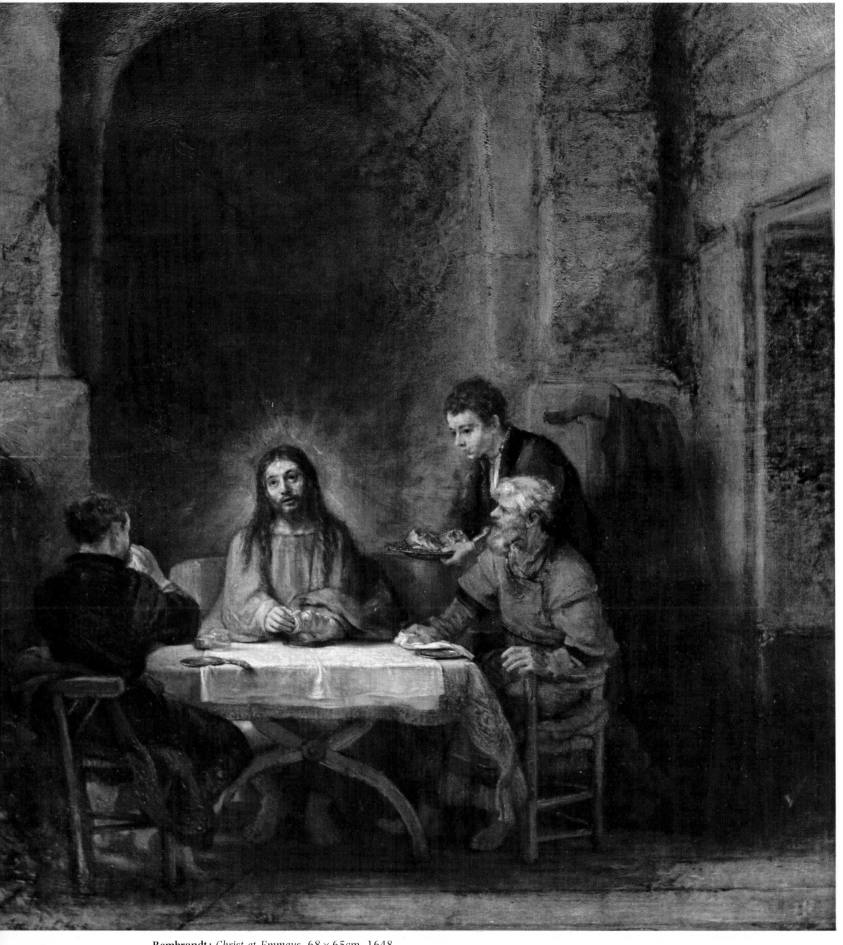

Rembrandt: *Christ at Emmaus*, 68 × 65cm, 1648

appearing before the apostles. There is a noticeable similarity between this painting and Leonardo's *Last Supper*, which again illustrates how Rembrandt was able to assimilate the ideas of other artists, and transform them in his own unique manner.

Besides painting subjects from biblical history, Rembrandt also chose a number of subjects from ancient and mythological history. Two early examples are *The Rape of Proserpine* and *Ganymede*, which, like his contemporary religious works, flout academic conventions of representation. Proserpine is

OPPOSITE **Rembrandt**: *Ganymede*, 171 × 130cm, 1635

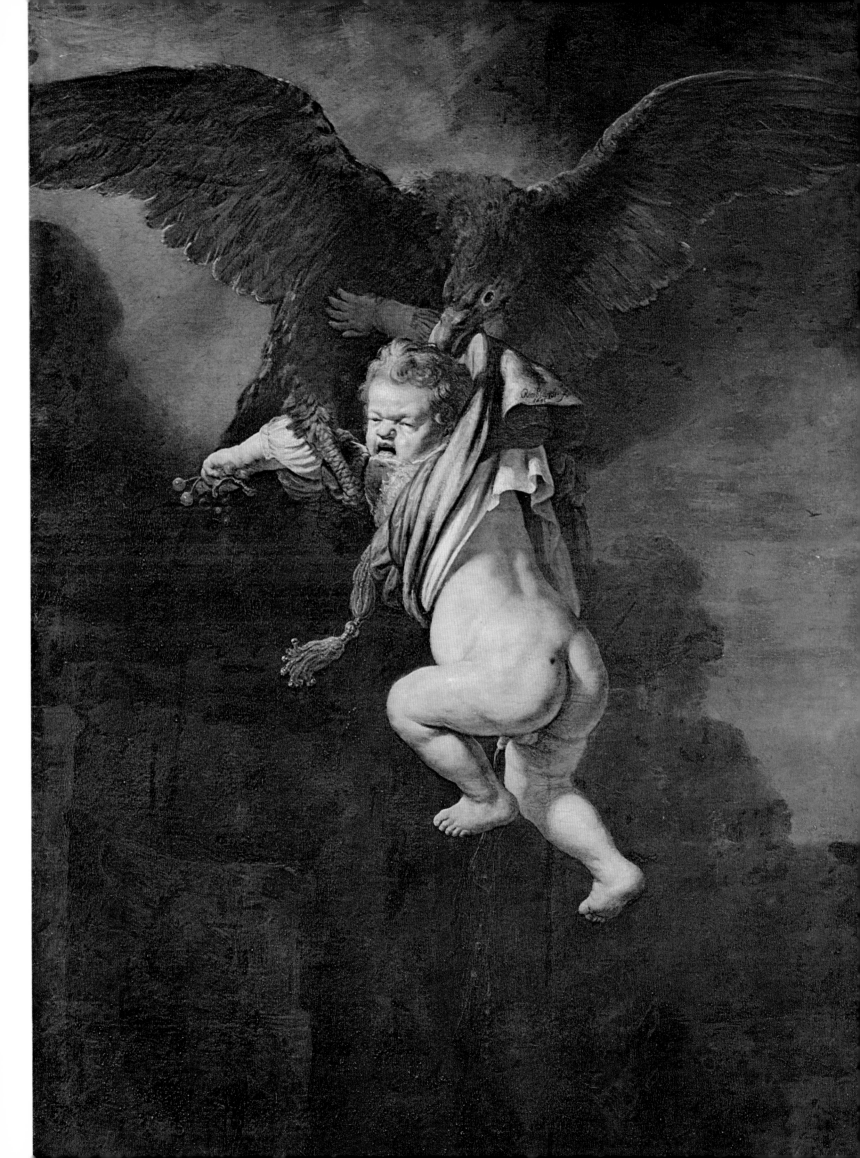

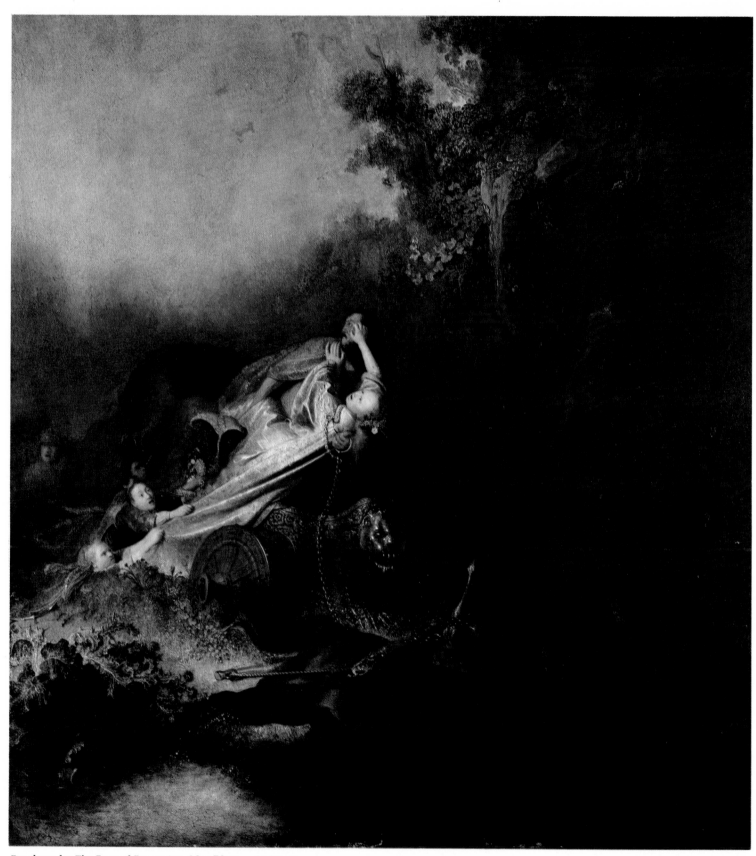

Rembrandt: *The Rape of Proserpine*. 83 × 78cm. *c*.1628–9

actually struggling against her captor, instead of abandoning herself to him, her arms flung out in ineffectual revolt, which is the way she would have been shown in a more conventional painting. Similarly, Ganymede, so far from being the boy whose good looks charmed Zeus, is a screaming, urinating child.

The same spirit animates the only important commission for a historical painting which Rembrandt ever received, *The Conspiracy of Julius Civilis*, which was intended to form part of the scheme of decoration in Amsterdam's newly built town hall. Julius Civilis is shown in full face, rather than in profile, which would have concealed the fact that he has one

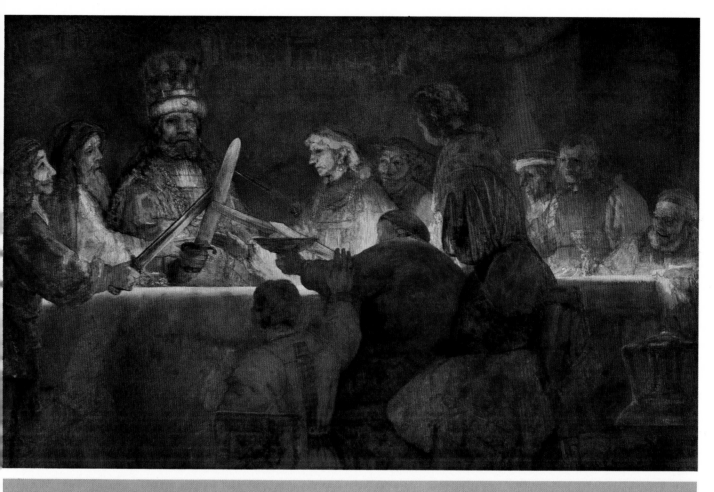

This painting, of which only a fragment survives, was
commissioned to decorate the new town hall at
Amsterdam. It embodies the seventeenth-century
theory that certain events in ancient history are pre-
figurations of modern occurrences. Thus, the Batavians,
a tribe who rose in revolt against their Roman
oppressors under the leadership of Julius Civilis, were
seen as the precursors of the Dutch, who had recently
won their independence from the Spanish.

Rembrandt had repeated difficulties with the burgo-
masters, and eventually took his painting back follow-
ing some disagreement. The gap in the decorative
scheme was hastily filled by a work by a German artist,
Juriaen Ovens, and Rembrandt's work was never
returned to the place for which it was originally
destined. Why was Rembrandt's picture so evidently
disliked? The answer probably lies in the fact that the
painting broke with classical canons of history paint-
ing: Rembrandt shows Julius Civilis with only one eye,
in accordance with documentary sources on his life,
instead of disguising the embarrassing deformity, as
Ovens did. Also, the style of the work, with its deep
chiaroscuro and indistinctness of form, was entirely at
variance with the rest of the paintings, which were
more Rubensian in character, and lighter in tonality.
The idea of evoking the importance of a historic
moment through the use of light, rather than gesture,
or expression, had yet to be appreciated.

eye missing. His companions resemble a race of trolls,
entirely lacking the classical dignity thought appropriate to
such a subject. Yet the work does possess great dramatic
power; the significance of the moment is conveyed through
the brilliantly glowing centre of the composition, contrasted
with the gloom of the background.

The Amsterdam town hall commission was quite a rare
event in seventeenth-century Holland. Usually, in preference
to ancient history, Dutch painters found plenty to portray in
their own recent history. Indeed, portraits of the period often
have a heroic dimension. The group portrait, usually com-
missioned to commemorate the governors of guilds,
charitable institutions, or private militia companies, was
particularly suited to the attempts to create a modern form
of history painting. Early examples of this type of work
generally look rather stiff and formal to us today. This may
be because the painter of these portraits had to contend with
the problem of how to invest each member of the group with
equal importance, while retaining some sort of pictorial
unity. All too often this meant rows of faces of approximately
the same size, showing very little expression or emotion. It
was Frans Hals who first started the move towards a freer
form of group portrait with his *Banquet of the Haarlem
Militia Company of St. George* of 1616, which contained an
unusual degree of animation and movement. But it was not
until Rembrandt was asked in 1648 to paint the Shooting
Company of Captain Frans Banning Cocq, in the work now
known as *The Night Watch*, that this trend in portraiture
reached its culmination. The bustle and commotion of the
picture have transformed the group portrait from a static

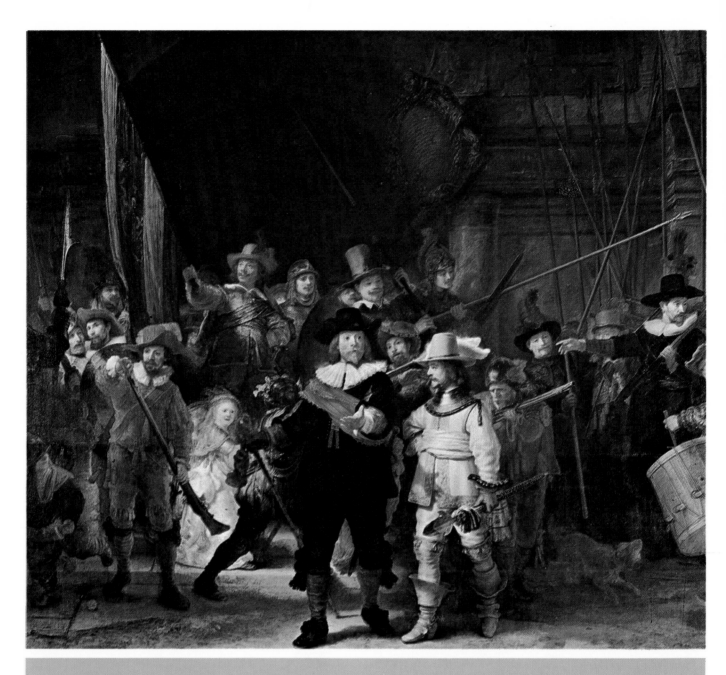

Rembrandt: *The Night Watch*, 359 × 438cm, and details pages 19, 20–1, 1642

This well known painting has suffered from a certain misrepresentation. It is not a painting of the night at all, but is set in the daytime. The title came to be applied to the work long after it was painted by those misled by its dark tonality. The canvas was also drastically cut down on all four sides in 1715 when it was transferred from its original home to the town hall in Amsterdam. Comparison with an early copy made by Gerrit Lundens shows how the delicate symmetry and balance of the picture was destroyed by this treatment. The perspective scheme, with its vanishing point in the archway was upset when a large portion was cut from the left hand side.

Rembrandt was commissioned to portray the private militia company of Captain Frans Banning Cocq. in 1642. The painting was to be hung in the Guildhall of the Companies of Riflemen, who were collectively termed 'kloveniers'. The girl running through the crowd in the background carries a brace of fowl attached to her belt, with the claws prominently displayed. This may be intended as pun as the word for claw in Dutch, *klauw*, is close to 'klovenier'. The riflemen were men of action, and Rembrandt found it appropriate to depart from more static forms of group portraiture to show the moment when the company is preparing to march out. In the foreground, Captain Cocq. gives orders to Lieutenant Willem van Ruytenburgh. The background is a mass of agitation, bathed in dramatic contrasts of light and shade.

depiction of group members into a record of the particular moment when they are assembling for action. The painting was, perhaps, rather too revolutionary in format to be assimilated into the mainstream of Dutch portraiture, for few artists after Rembrandt ever tried to emulate its treatment in their group portraits. In any case, from about 1640 onwards, commissions to paint militia companies began to decrease as companies were disbanded following peace with Spain. From thenceforth, Dutch burghers chose to be represented as syndics rather than soldiers. Rembrandt's

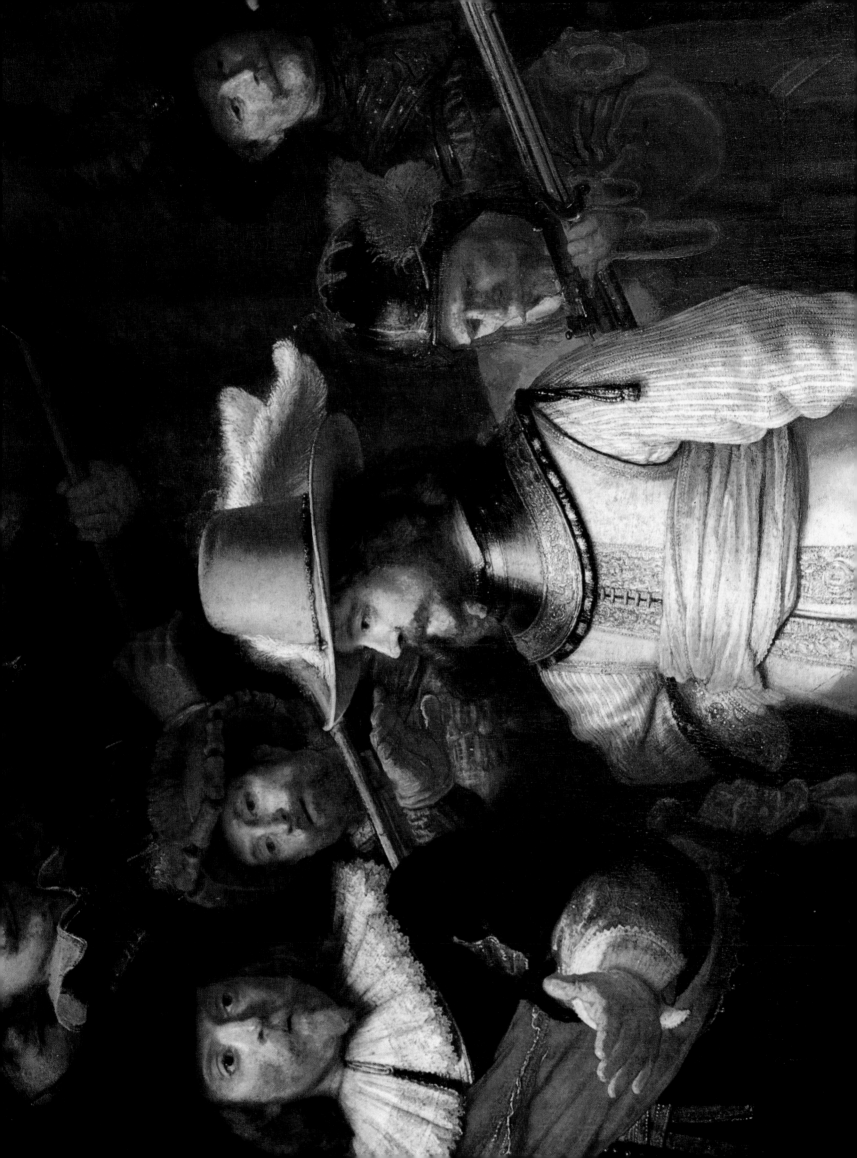

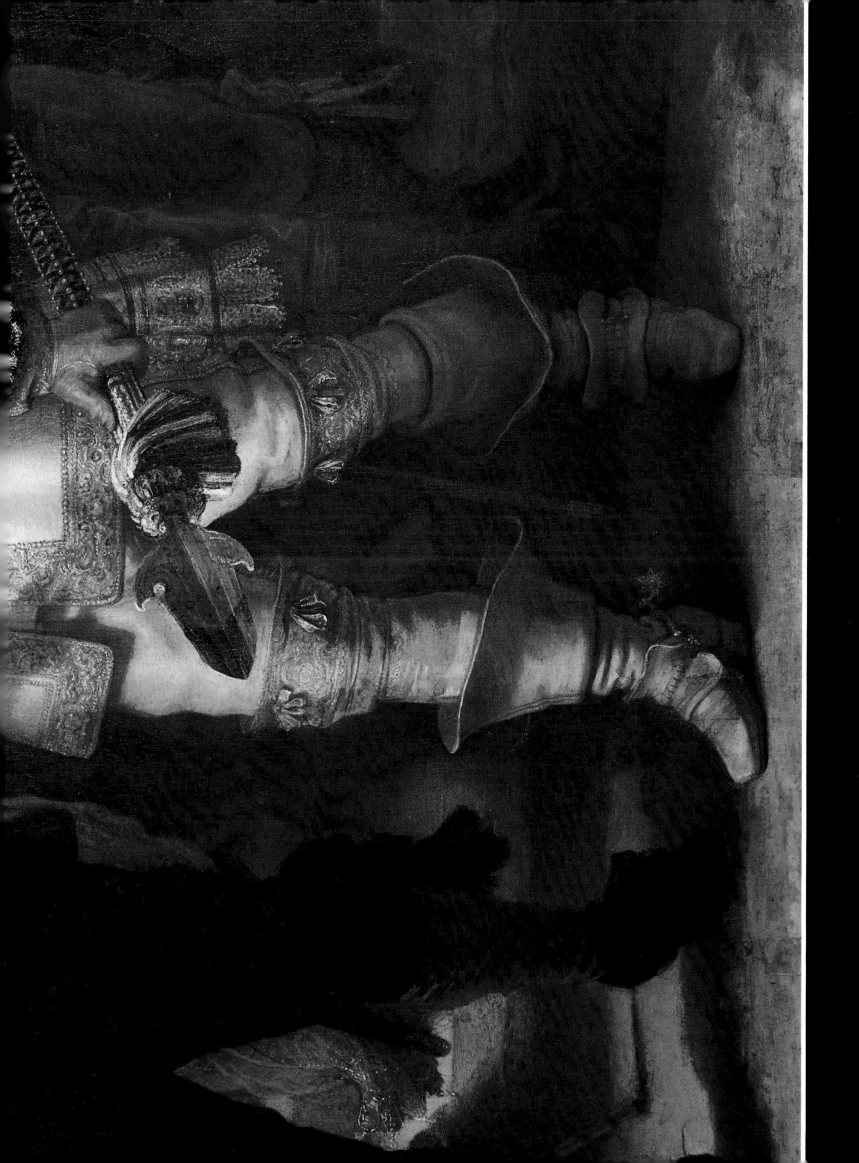

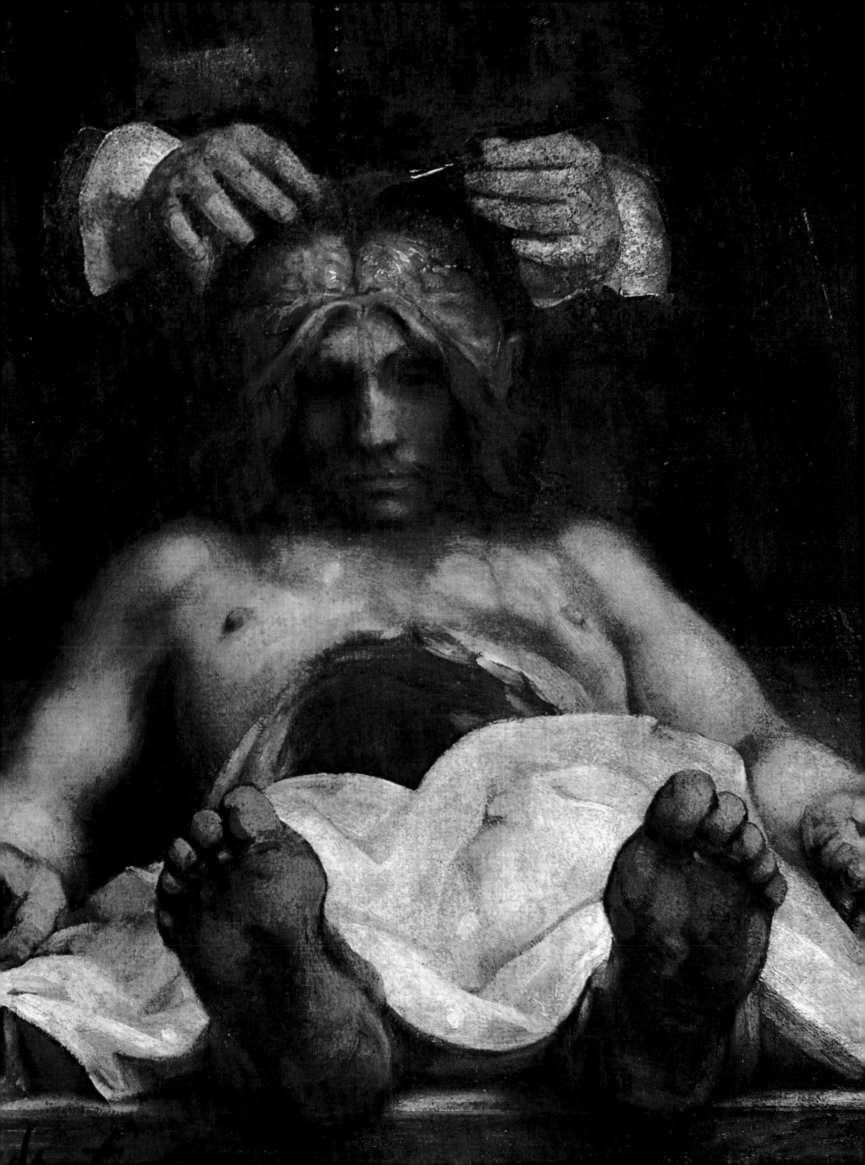

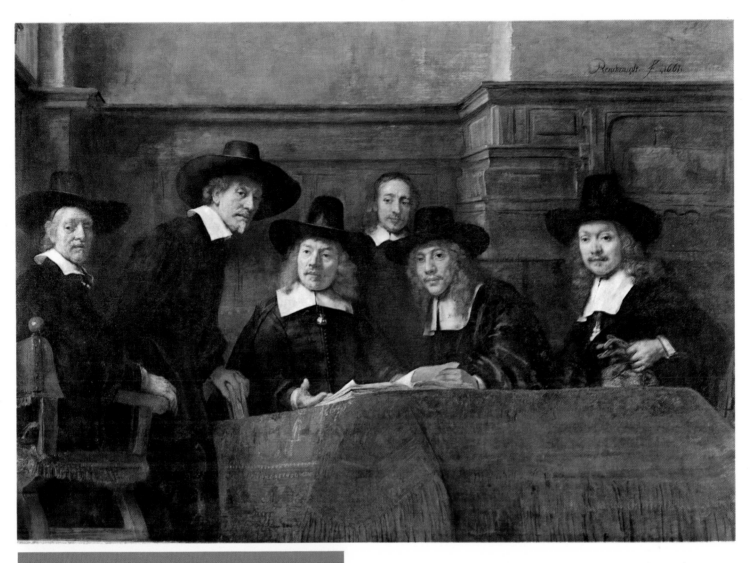

Rembrandt: *The Syndics,* 185 × 274cm, 1662

The men represented here are probably the members of
the board of the Draper's Guild, who inspected the
quality of cloth produced in the city, and were
responsible for maintaining standards of manufacture.
One of Rembrandt's contemporaries described the work
as 'simply five gentlemen in black who are sitting to
have their portraits painted'. Yet following generations
have tended to read more of a narrative into the
picture, commenting on the expressions on the faces,
and even advancing the theory that the syndics are
reacting spontaneously to the spectator. Critics have
pointed out that the syndics all appear to be concerned
with some sudden event, and that the man on the left
of the table seems to be rising to his feet in surprise.
What ever the construction one puts on the picture,
there is no doubt that Rembrandt deployed an in-
genious device for unifying the portrait in giving the
work an emotional focus. He also expended a great
deal of effort in shifting the position of the figures to
make a coherent composition, where action is stabilized
by the calm horizontals and verticals of the surround-
ing architecture. The choice of a low viewpoint adds
distance and authority to the sitters, and is appropriate
to a painting which was probably hung high up on a
wall.

Syndics was painted almost twenty years after *The Night
Watch,* and shows a group of men who have been identified
as the board of governors that regulated the drapers' guild
in Amsterdam. It is a more focused, less scattered composi-
tion than *The Night Watch.* Yet there is still an element of
ambiguity represented by the movement of the syndic to the
left of the table, which has given rise to a great debate about
the interpretation of the picture. The painting does, how-
ever, present a solution to the problem of how to give equal
weight to each of those portrayed. Because each of the
syndics is reacting to an event, there is a narrative linking
them together, which is lacking in even such impressive
group portraits as Hals' late *Regent* pieces.

Rembrandt's fame in Amsterdam was built upon his
achievements as a portraitist, rather than as a religious or
history painter. His recognition followed the completion of
his first large-scale portrait group, *The Anatomy Lesson of
Dr Tulp,* in 1632, which depicted the famous doctor
dissecting an arm. Years later, in 1656, he returned to the
dissection theme, and portrayed Dr Tulp's successor lecturing
to the guild of surgeons. Dr Joan Deyman is demonstrating
the dissection of the brain. Only a fragment of this painting
survives, ironically enough showing Dr Deyman to have
been the victim of decapitation himself when the picture
was cut down. The face of his assistant on the left shows an
intense absorption in what is being carried out before him.
The realism of his expression is rather at variance with his

OPPOSITE **Rembrandt:** *The Anatomical Lesson of Dr Joan Deyman,*
100 × 134cm, 1656

23

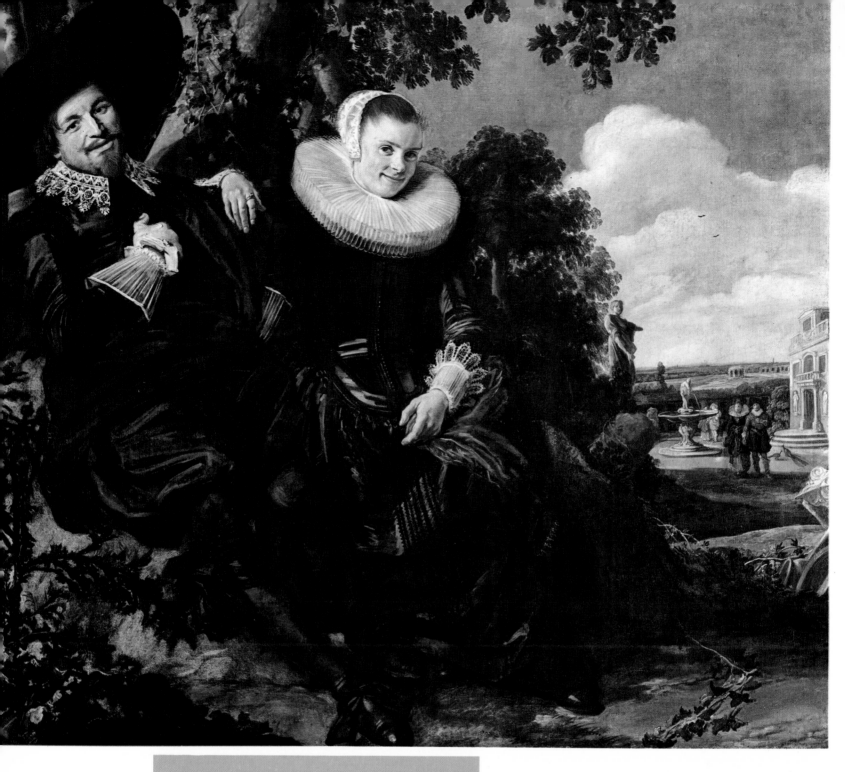

Hals: *Married Couple*, 140 × 166·5cm, 1622

This is undoubtedly a marriage portrait, as the woman is proudly displaying her wedding ring on her right index finger. Since the sixteenth century it had been customary to portray lovers in gardens, and Hals' portrait clearly follows in this tradition. Unlike his later work, there is much overt symbolism in this painting: the prominent branch of ivy in the foreground denotes steadfast love and faithfulness, and the thistle is similarly symbolic of love and fidelity. A vine clings to the tree behind the couple, reflecting the way in which the woman will cling to the man in marriage, and echoing to some extent the pose of the figures, where the woman is literally leaning on her husband. In the background, the parading peacock is emblematic of the Goddess Juno, protectress of marriage, while the half buried urn may serve as a *memento mori* in the midst of this conjugal felicity. The couple has been identified as Isaac Massa and his bride Beatrix van der Laen, who were married in 1622.

stance, which is a stock pose belonging to more formal portraiture.

Only buildings the size of guildhalls could accommodate large corporation pictures. Family portraits, intended for the house, were generally carried out on a smaller scale. The Dutch seem to have been particularly fond of double portraits of married couples, or of single portraits of husband and wife which could be hung as pendants to each other. More than thirty pendant portraits by Hals can be identified, that is more than a quarter of his existing paintings. Double portraits and pendant portraits are often replete with symbolism. Two good examples are Hals' *Married Couple* and Metsu's portrait of himself and his wife. Overt symbols of the type these portraits contain act as an extension of meaning, and are intended to convey further information about the sitter's personality or situation in life. They would have had a very precise connotation for the seventeenth-century Dutch who would have known, for instance, that ivy in a painting represented marital happiness and fidelity. Of course, not all portraits relied on devices such as these: they

Metsu: *The Artist and his Wife*, 35·5 × 30·5cm, 1661

This painting has been identified as a portrait of the artist and his wife. They are not shown at home, but sitting in a tavern, with the hostess chalking up the reckoning on the board in the background. Naturally, it carries associations of Rembrandt's double portrait of himself and Saskia, where Rembrandt turns towards the spectator with his wife in his lap, raising a glass of wine in celebration. The Rembrandt portrait has been interpreted as a scene from

the life of the Prodigal Son, which seems likely since tavern scenes often were overlain with references to parables, and the Prodigal Son was a great favourite with artists. It could be that the Metsu should be seen in the same light. Whatever its ultimate significance, there is no denying the erotic overtones of the woman's gesture with her right hand and the two cherries and the empty bird-cage above her head, which was traditionally associated with wanton behaviour.

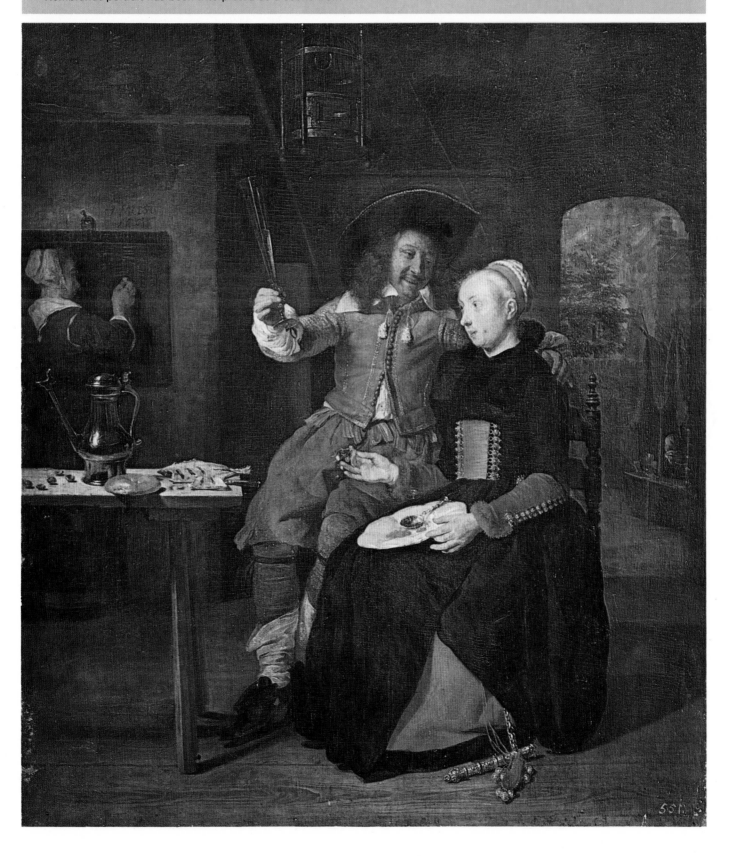

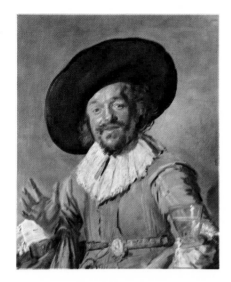

Hals: *The Merry Drinker*, 81 × 66·5 cm, *c*.1628–30

are conspicuously absent from Hals' later works, and Rembrandt very rarely uses obvious pictorial metaphors. His double portrait entitled *The Jewish Bride*, for example, relies on the suggestive quality of the paint, and the warm glow of the central part of the picture to evoke a mood of marital tenderness. Hals' *Nurse and Child* contains symbolic reference, although of a kind which is inextricably linked to the whole structure of the painting. Any depiction of a

Rembrandt: *The Jewish Bride*, 121·5 × 166·5cm, and detail pages 28–9, c.1660–5

The present title of this painting came into being as late as the early nineteenth century and was the result of the discovery that the hands of the pair are shown in an attitude of Jewish betrothal. Yet whether or not the painting is a formal marriage portrait remains obscure. Rembrandt may well have painted a bridal couple, but he has endowed them with a symbolic significance that transcends the pictures function as a mere portrait. Suggested sources for the composition have been found in biblical history. One theory has been advanced that the couple represent Isaac and Rebecca, as there is a close similarity between this painting, and a drawing by Rembrandt which is based upon Raphael's work in the Vatican, *Isaac and Rebecca Spied upon by King Abimelech*. It could also be that Rembrandt was alluding to the story of Jacob and Rachel, since there is a painting by one of Rembrandt's contemporaries with that title, which resembles this picture. Whatever the exact connotations of the painting, there is no doubt that it is a moving depiction of marital love, and that the handling of paint is masterly.

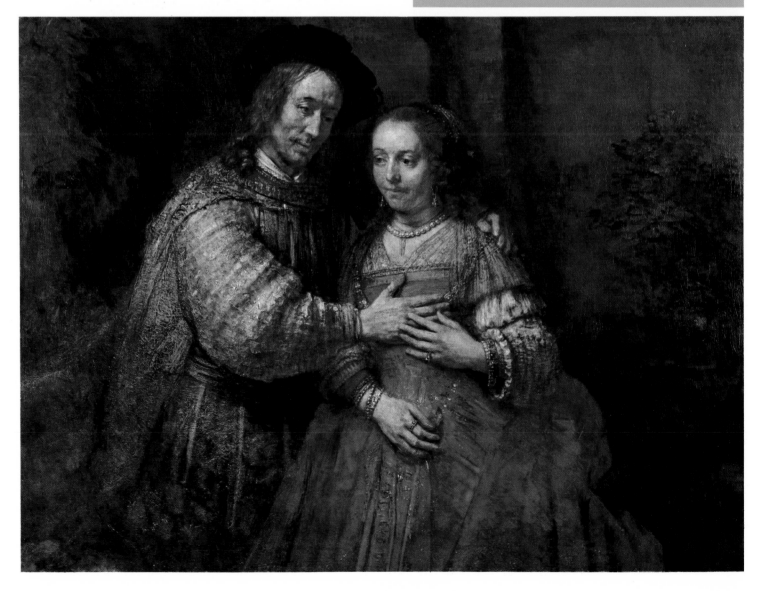

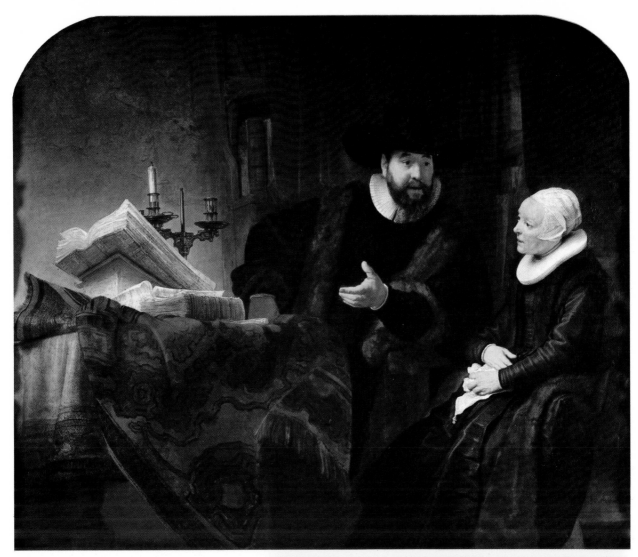

Rembrandt:
*The Mennonite
Preacher,
Cornelis Anslo,
and a Woman,*
176 × 210cm,
1641

woman and child carries overtones of Madonna and Child, and here the analogy is reinforced by the fact that the woman (who may be the child's nurse or mother) is handing the child an apple, a gesture definitely associated with Madonna and Child paintings. In Hals' hand, however, the movement becomes a spontaneous one; it is as though the child was just about to grab the piece of fruit when the action was interrupted by the appearance of a spectator.

The same sense of suspended animation pervades Rembrandt's portrait of the preacher Cornelis Anslo and a woman. Traditionally, the woman has been described as Anslo's wife, an identification which, if correct, would enable us to view the painting as a marriage portrait. The veracity of this suggestion must remain dubious, however, in view of the fact that this is a portrait of the minister preaching, and is not set in the comforts of home surroundings. The woman may have been included to demonstrate the effects of Anslo's rhetoric, which Rembrandt would certainly have heard, since he was himself a sympathizer with Anslo's Mennonite sect. It looks as though Anslo may be comforting the woman, perhaps recently widowed, as she is clutching a handkerchief. The presence of the candle, symbolic of the transience of human life, might lend support to this theory. A low angle of vision, and the use of the table placed between the subject and the spectator, invests the preacher with a certain dignity and distance, and is a format Rembrandt used again successfully in the *Syndics*.

Often, in group and double portraits there is some implied dialogue between characters, which gives scope for the

Hals: *Nurse and Child,* 86 × 65cm, *c.*1620

OVERLEAF **Rembrandt:** *The Jewish Bride* (detail)

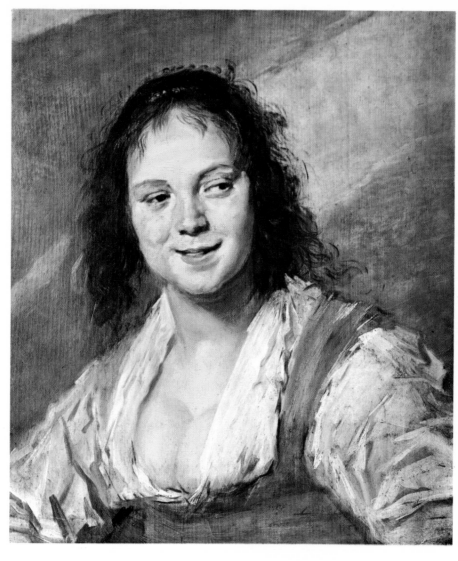

depiction of expression and gesture. In the single portrait,
artists are not always presented with this possibility of
narrative, although Hals, the master of fleeting expression,
sometimes gives the feeling that his characters are reacting
to events outside the picture space: both Malle Babbe's
demonic laughter and the Gypsy Girl's seductive smile are
directed at an unseen observer. All Hals' sitters radiate an
extraordinary vitality which is never found in more con-
ventional portraiture. Willem van Heythuyzen's very pose as
he tips back on his chair is emphatically spontaneous. The
forceful diagonals of the composition add to the strong sense
of movement. Hals' portrait of Willem Croes was painted
twenty years after that of van Heythuyzen, and also conveys
the impression of a robust personality. The freedom of brush-

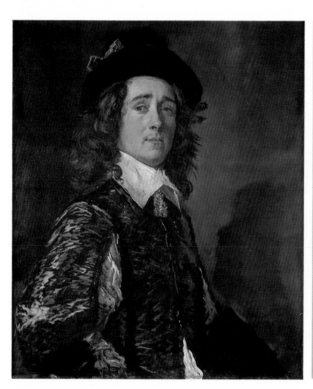

Opposite **Hals:** *Malle Babbe,* 75 × 64cm, c.1645

One can hardly forget the strangely contorted face of Malle
Babbe; Hals has caught her demented laugh and fixed it
forever in this potent image. Malle Babbe was a real life
character popularly known as the Witch of Haarlem, who
lived in Hals' home town. It is evident that this cannot have
been a commissioned portrait, and Hals probably saw his
subject as offering an excellent opportunity for character
study. The picture has been interpreted as a personification
of drunkenness, in view of the large tankard Malle Babbe
holds in her right hand. Yet is hard to believe that her
grotesque expression is due entirely to drink. The owl
perched on her shoulder may provide a clue: although some
emblem books link owls with drunk people, others associate
them with the general attributes of stupidity and vulgarity. It
is difficult for us today not to read some psychological
dimension into the work, and see it as a study in derange-
ment.
 The date of the painting has recently been conjectured as
1645, as it appears on a copy made by Gustave Courbet in
the nineteenth century.

LEFT **Hals:** *Jasper Schade van Westrum,* 80 × 67cm, *c.*1645

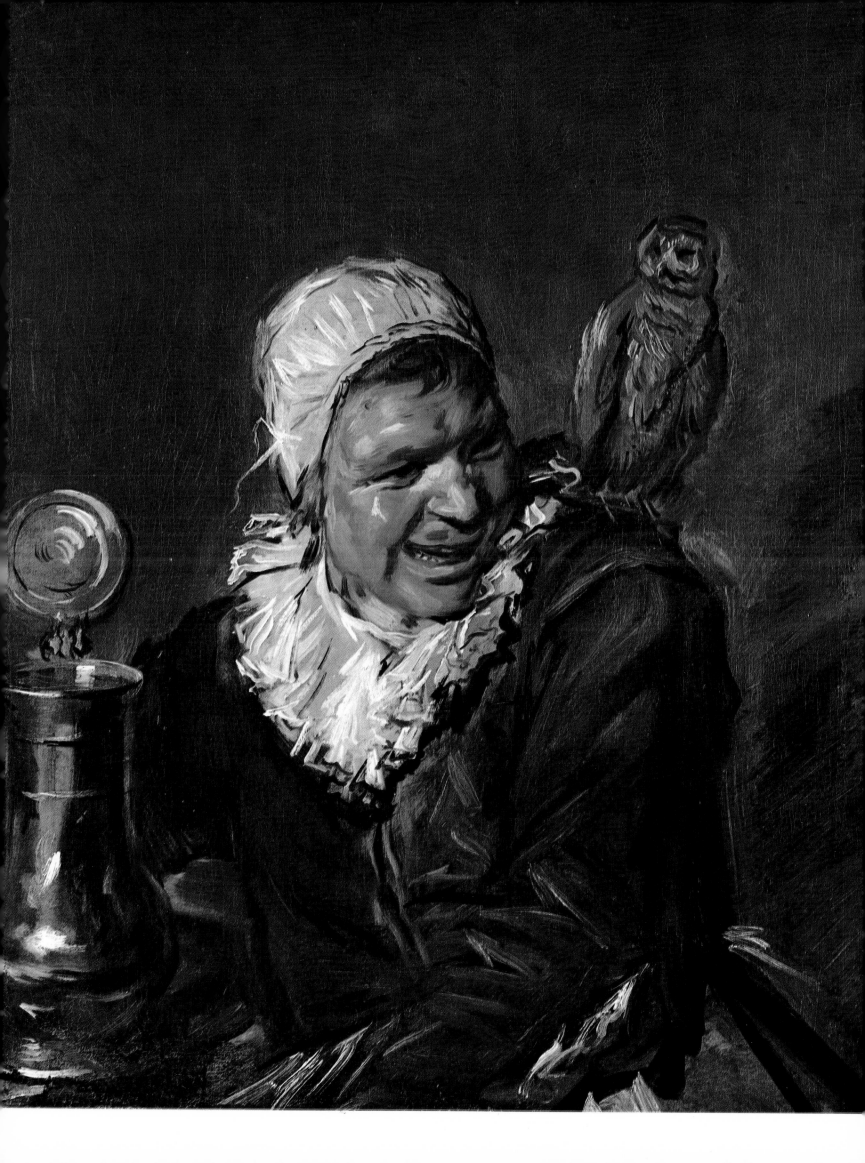

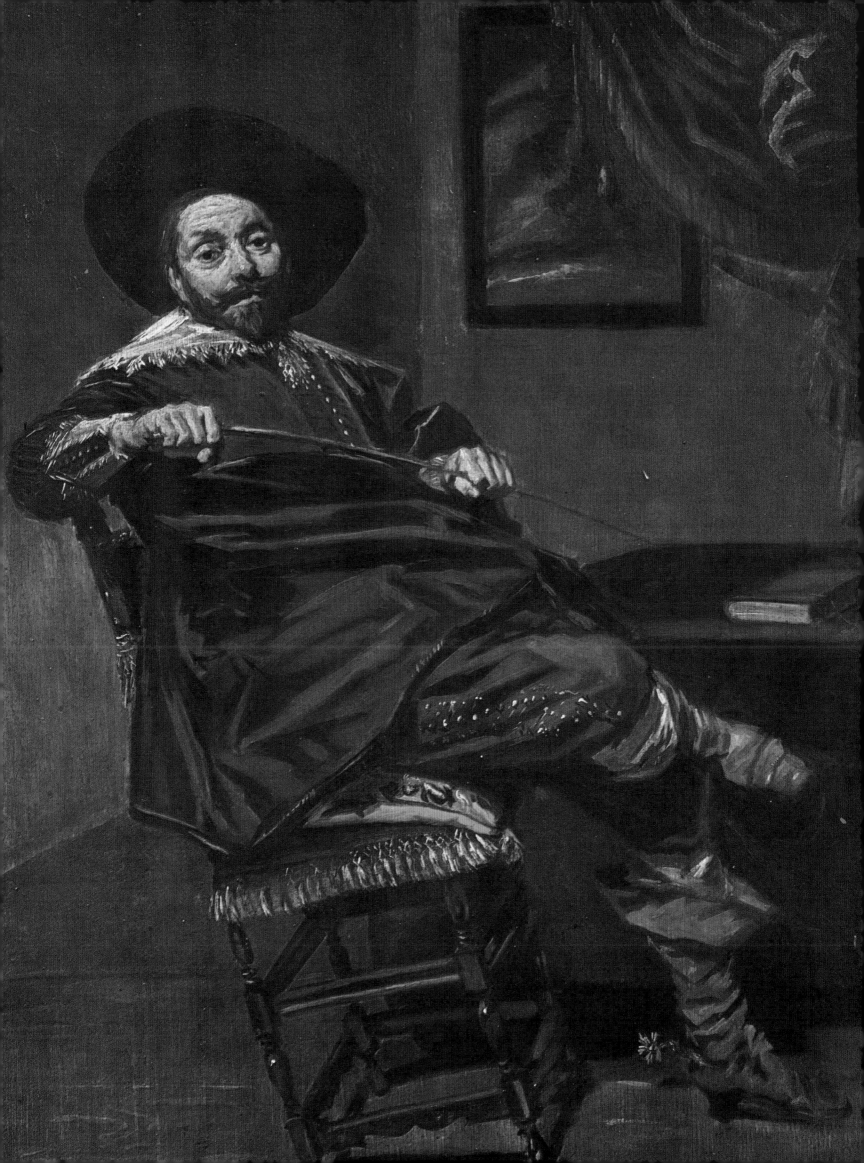

Opposite **Hals:** *Willem van Heythuyzen,*
46·5 × 37·5cm, c.1640

Willem van Heythuyzen was a wealthy Haarlem
merchant who endowed a small home for old
people in the town. He was a personal friend of
Hals, who painted him on two occasions: once,
in about 1625, when he was shown standing in
Hals' only known life-size, full length work, and
again about fifteen years later, in this work,
where the mood is more intimate and casual.
 There is a characteristic show of skill in the
way in which the strong diagonal movement of
the sitter's body is counterbalanced by the hori-
zontals and verticals of the picture frame and
table. The instability of pose and expression form
a marked contrast to more conventional portraits
by artists such as Miereveld, who felt themselves
to be constrained by the demands of portraiture
to present a static and dignified record of their
sitter's features.

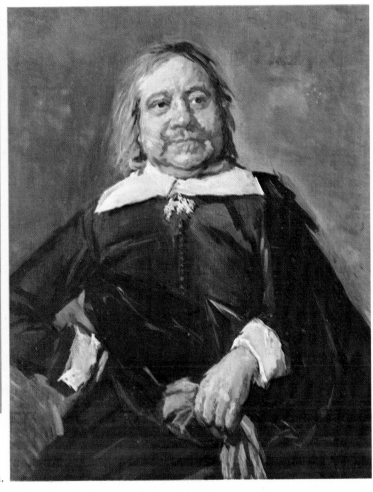

RIGHT **Hals:** *Willem Croes*, 47 × 34cm, c.1658

BELOW **Rembrandt:** *Margaretha de Geer*, 130·5 × 97·5cm,
c.1660

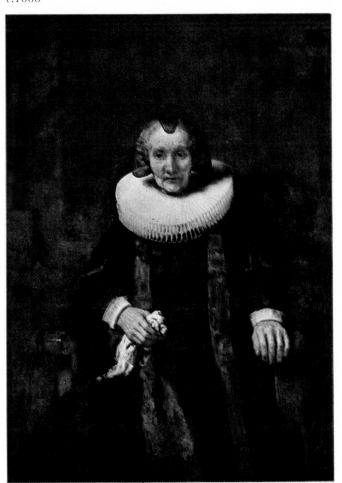

stroke puts one in mind of the advice Hals is supposed to
have given his pupils: 'You must smear boldly; when you
are settled in art, neatness will surely come by itself.' The
sheer bravado of this approach does much to divert our
attention from inaccuracies in drawing; in this case, the
strange proportion of Croes' right arm.
 Most of Hals' sitters were Dutch burghers, rather than
eminent statesmen or philosophers, although on one
occasion he portrayed Descartes. On the whole, his art is one
of surface effect, not psychological exploration. The emphasis
could not be more different from that of Rembrandt. The old
man in Rembrandt's portrait of 1643 sits shrouded in
mysterious gloom. His surroundings, the table with the
closed folio, and the candle, suggest that he has just finished
reading and is sunk into contemplation. His appearance
resembles that of a rabbi; Rembrandt during his Amsterdam
years developed a passionate interest in studying the
inhabitants of the Jewish quarter, where he lived. For him,
they were the authentic people of the Bible, and he often
incorporated their features into his religious works. This
painting also touches on another consistent interest in
Rembrandt's painting: his obsession with old age. The
countless studies he made of old people, beginning with his
mother and father in the guise of prophet and prophetess,
meant that when he was actually commissioned to paint an
old person, the approach was often particularly sensitive.
The portrait of Margaretha de Geer, wife of the Dordrecht
merchant Jacob Trip, whom Rembrandt also depicted in a
pendant portrait, is a good example of his faithful observation
applied to formal portraiture. The hands and head surrounded

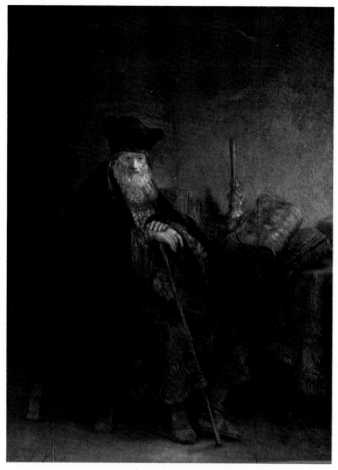

Rembrandt: *The Old Rabbi,* 70·5 × 53·5cm, 1643

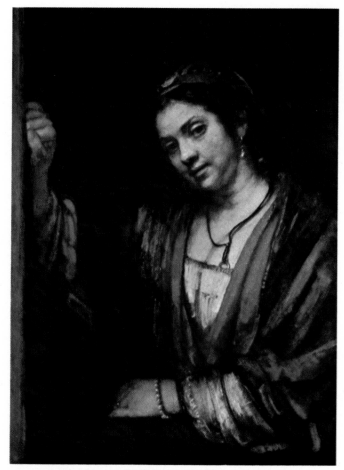

Rembrandt: *Hendrickje Stoffels at a Window,* 86 × 65cm, 1659

by a stiff white ruff stand out against the dark background, showing wrinkles and veins which have been rendered with anatomical precision. This picture may be usefully compared to the portrait of Elizabeth Bas, where the treatment is very similar: head and hands are also isolated against dark, but the overall effect is so much harsher and sharper in outline. There has been some controversy in the past, about the attribution of this picture. Some scholars have maintained that the author of the portrait was Rembrandt, although nowadays it is generally thought to have been painted by Ferdinand Bol, Rembrandt's pupil, between about 1635 and 1640. Bol was very highly regarded as a portraitist in his own day, and received many important commissions, including one to participate in the decoration of the Amsterdam town hall. On the whole, his portrait style is crisper in outline, and smoother in texture than that of Rembrandt.

In Rembrandt's portrait of Hendrickje at a window, which is roughly contemporary with the Bol picture, the paint has been applied in broad fluent strokes, and in his *Man with a Golden Helmet,* paint has been used so generously as to give a relief effect to the pattern on the helmet. The man in this painting has been tentatively identified as Rembrandt's brother, Adriaen. Rembrandt frequently used members of his own family as models, often dressing them in exotic costume and portraying them as allegorical figures. Saskia was variously painted as Flora, Artemisia, and Bellona, and Hendrickje appears as Diana and Venus, and his parents as Old Testament characters. Several self-portraits show Rembrandt 'in character' as well: it has been suggested that the self-portrait of 1661 in the Rijksmuseum, in which the

Bol: *Elizabeth Bas,* 118 × 91·5cm

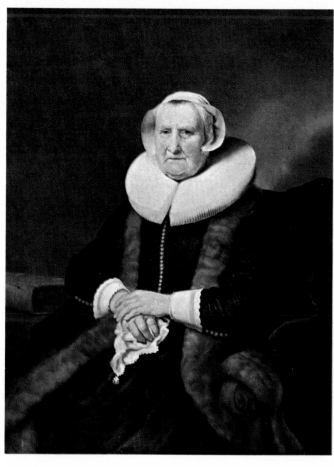

OPPOSITE **Rembrandt:** *Man with a Golden Helmet,* 67 × 50cm, *c.*1650

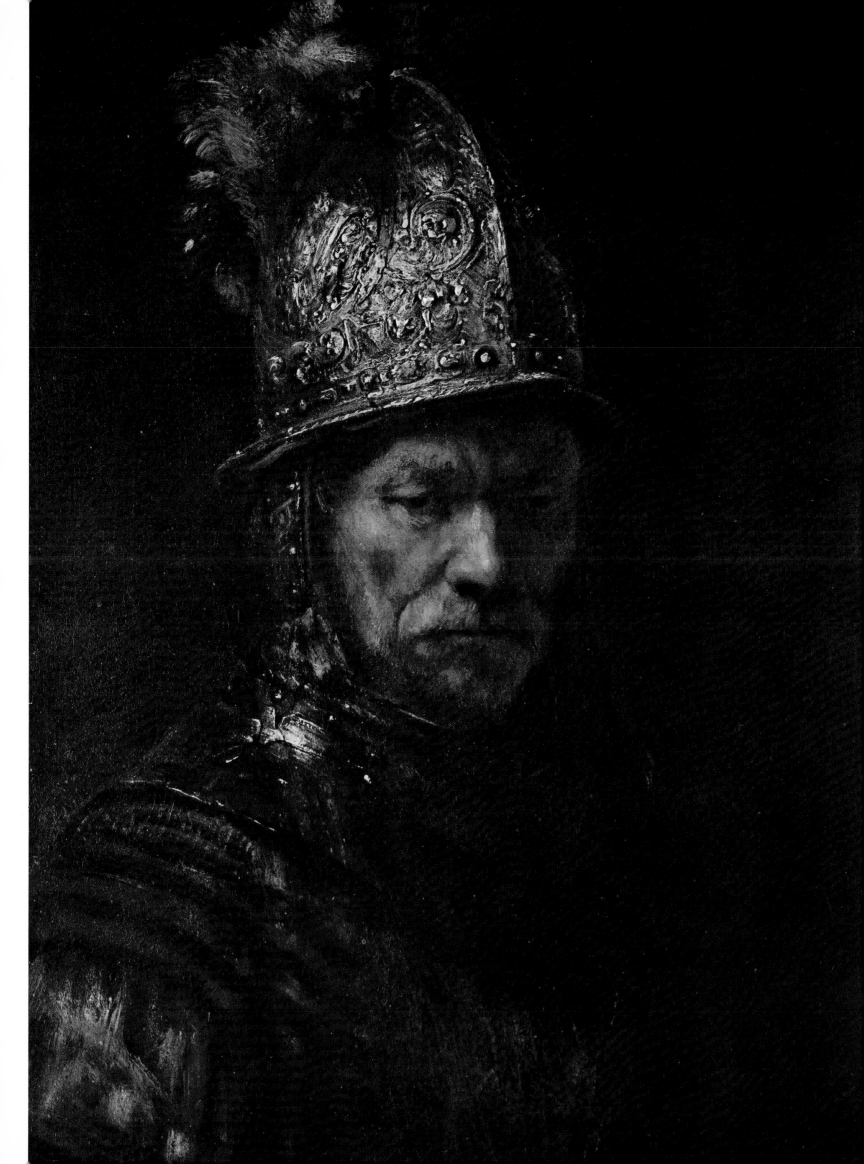

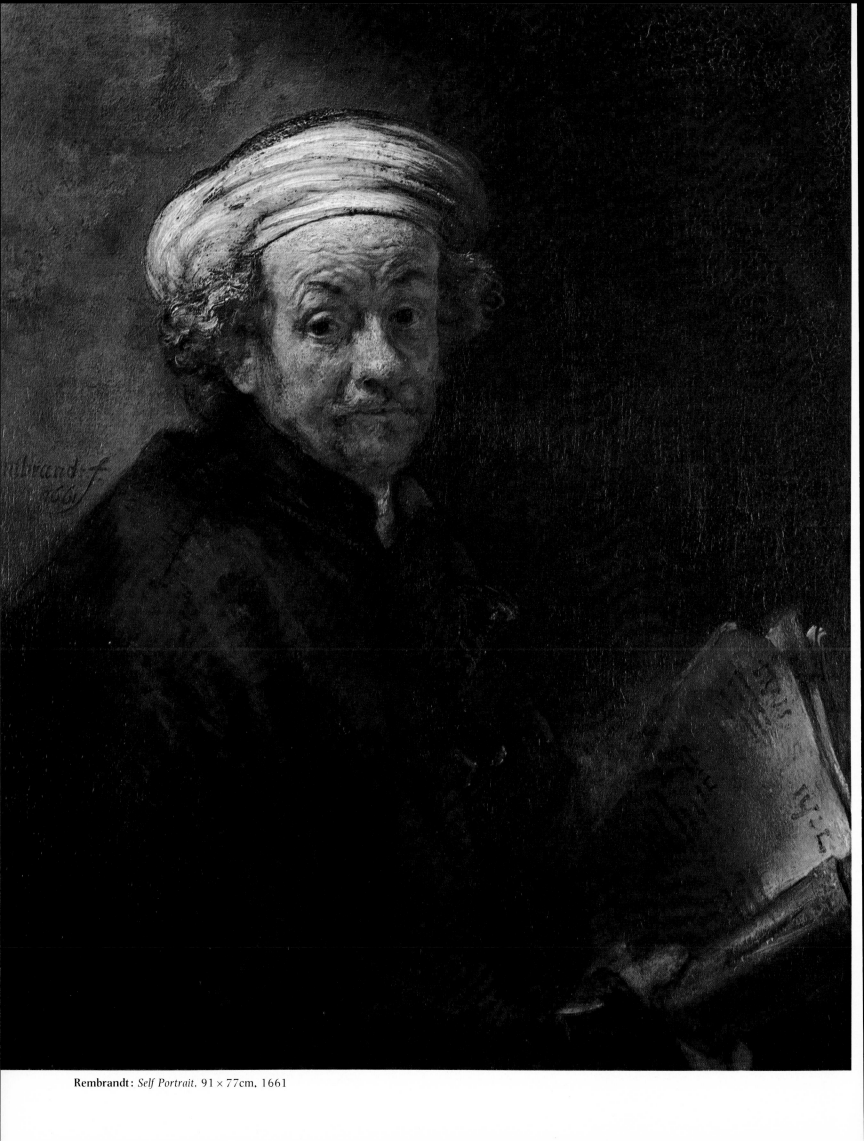

Rembrandt: *Self Portrait,* 91 × 77cm, 1661

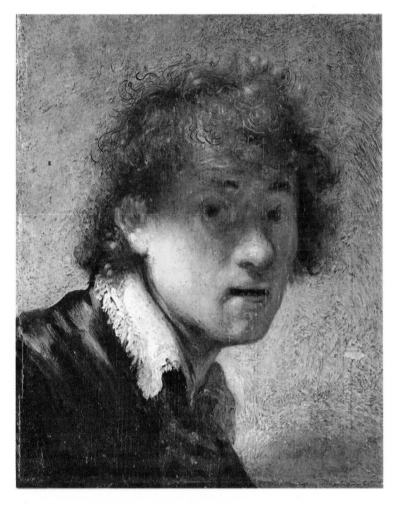

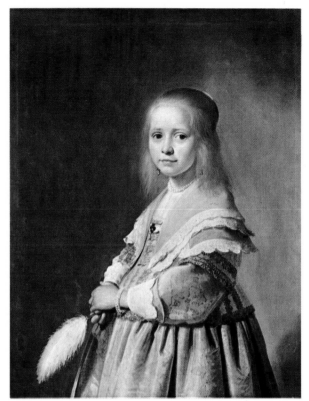

Verspronck: *Portrait of an Unknown Girl,* 82 × 66·5cm, 1641

LEFT **Rembrandt:** *Self Portrait,* 93 × 68cm, 1629

artist wears a turban, and holds a manuscript written in Hebrew lettering, represents Rembrandt as St Paul. This painting of the artist in middle age makes an interesting contrast to the more direct, simple self-portrait he painted at the age of twenty-three. The great number of his self-portraits is unique. It is true that Rembrandt was not the only artist of his day to paint himself, but his output was enormous. It has been estimated that he produced about two self-portraits for each year of his active artistic life, and they provide a remarkable visual autobiography, for which there can have been little public demand.

Although we think chiefly of Hals and Rembrandt when we try to create a picture of Dutch seventeenth-century portrait painting, they are not really representative of the majority of portrait painters in Holland at that period. Hals' activity was restricted mainly to his native Haarlem, and Rembrandt's popularity as a portraitist in Amsterdam never entirely eclipsed the more conventional forms of portraiture purveyed by his contemporaries. Early in the century the chief source of patronage for the portraitist was the court circle at The Hague, and painters like Michel van Miereveld, who produced a very great number of portraits, were able to commit to canvas the features of the House of Orange and their entourage. It was not long, however, before Amsterdam and Haarlem developed as centres where a portrait painter could make a living. The work of Jan Cornelisz. Verspronck, who lived in Haarlem his entire life, proves that two rather different approaches to portraiture could be supported by one town. Looking at one of Verspronck's best known works, *Portrait of an Unknown Girl,* of 1641, it is as though the style of Verspronck's fellow townsman, Frans Hals, has been taken as a starting point, and a certain sleekness imposed on it. The sheen of the hair and silk dress and the translucency of the skin are features particularly suited to Verspronck's speciality of painting women and children.

Verspronck's contemporaries in Amsterdam, Bartolomeus van der Helst and Thomas de Keyser, set the tone of portrait

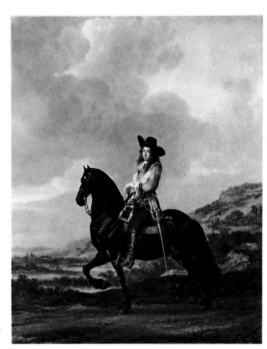

de Keyser:
*Pieter Schout
on Horseback,*
86 × 69·5cm,
1660

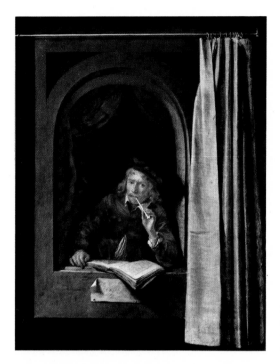

LEFT **Dou:**
Self Portrait,
48 × 37cm,
*c.*1645

painting in the capital city in the middle of the century. Van der Helst succeeded Rembrandt as the city's favourite portraitist in the 1640s, when popular taste turned towards the sophisticated elegance of Van Dyck's portrait style, with its bright, clear colours and smooth textures. Something of this flavour may be seen in Thomas de Keyser's portrait of Pieter Schout on horseback. Although de Keyser also painted group portraits (including one anatomy lesson) his talents were best deployed on single portraits, and especially equestrian portraits, which were rarely painted in Holland until his lifetime.

Many painters who had made their names in other branches of art also dabbled in portraiture. They include Gerard Dou, Gerard Ter Borch, Nicolaes Maes, and Casper Netscher, who are all better known for their paintings of everyday life. Gerard Dou, who worked with Rembrandt in Leiden in the 1630s, and who continued to paint in the highly finished Leiden style, produced a number of impressive portraits, among them, some interesting ones of himself. One showing the artist leaning out of a window, smoking a pipe, is a characteristic example of his style. The portrait lacks the psychological depth of Dou's master; it is as though the painter has turned himself into a kind of emblem, or still life study. Images of pipe-smoking were widely recognized as symbolic of *vanitas*, or the transience of life, in seventeenth-century Dutch art.

This particular composition – a figure at a window – was popularized by Dou, and is found in several contemporary genre paintings. By genre, we usually mean paintings of the incidents of everyday-life. The Dutch were more specific in their descriptions of such paintings, which were defined precisely according to their subject matter. Barrack-room scenes, brothel scenes, and outdoor parties – each formed a different category of painting. Such scenes are seldom as straightforward as they first appear, and they almost invariably point a moral, or illustrate a popular proverb. Although the style of these works may seem naturalistic, with carefully painted details, and convincingly rendered textures, they are not a realistic type of painting in the

Ter Borch: *Helena von Schalke as a Child,* 34 × 28·5cm, *c.*1644
Ter Borch: *Curiosity,* 76 × 62cm

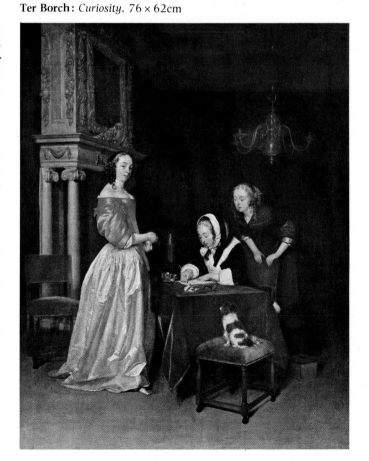

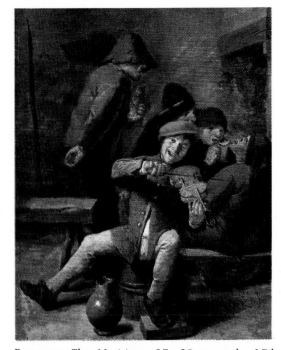

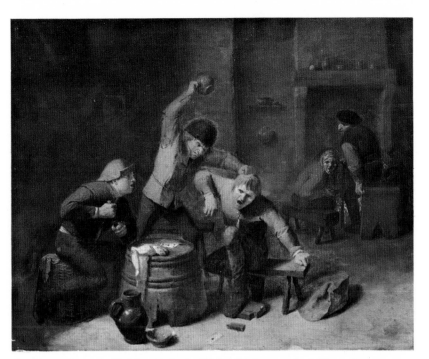

Brouwer: *The Musicians*, 27 × 20cm, early 17th century

Brouwer: *Peasants Fighting at Cards*, 26·5 × 34·5cm, early 17th century

modern sense. Dutch artists were selective in their view of the world around them, and though one frequently comes across ugly, grimacing peasants in tavern scenes, they are always given a picturesque veneer, and there are few examples of desperate, depressing poverty.

The genesis of peasant, or low-life subjects, may be seen in works by the Flemish artist, Pieter Bruegel. It is no surprise that Adriaen Brouwer, who first pioneered such paintings in Holland, was also Flemish by birth, although he moved to Haarlem while still in his teens. Brouwer is best remembered as a painter of tavern scenes and brawls, of which *Peasants Fighting* is a typical example. There is some implied narrative: one member of the party has cheated at cards, and a fight has broken out. The colour is laid on in broad areas, and, in contrast to Bruegel's evenly lit paintings, there are sudden juxtapositions of light and shade, which convey a powerful sense of drama. The same breadth of handling is seen in Brouwer's *The Musicians*. The expression of the foreground figure, who winks at the

spectator, could almost have been taken from a Hals painting, and it is highly probable that Brouwer was a pupil of Hals during his stay at Haarlem. It is possible that this work may represent the five senses of hearing, taste, touch, sight and smell. Hearing is accorded the most prominent place in the front of the picture. Personifications of the senses are very frequent in Dutch painting of this period; Judith Leyster, another pupil of Hals, may also have had the sense of hearing in mind when she painted *The Flute Player*. Brouwer's influence extended to the genre scenes of Adriaen van Ostade, a fellow member of Hals' circle, who, during the 1630s specialized in depicting peasants carousing in interiors, as well as families in messy homes.

Philips Wouwerman, although chiefly remembered as a landscape artist, also executed a number of genre scenes. They are usually set out of doors, and feature vignettes of peasant life. *The Quack at the Fair* is crammed full of incident. In the foreground, the quack himself attempts to sell his wares assisted by two monkeys, emblematic of human folly,

Wouwerman: *The Quack at the Fair*, 43 × 57cm, mid-17th century

Adriaen van Ostade: *Family of Peasants in an Interior*, 43 × 36·5cm, 1647

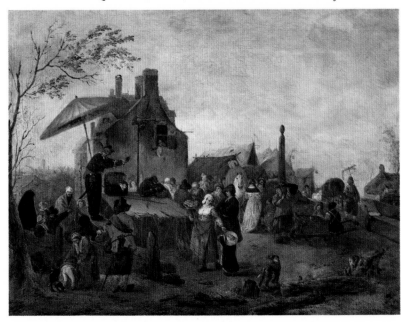

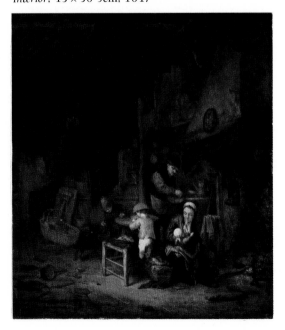

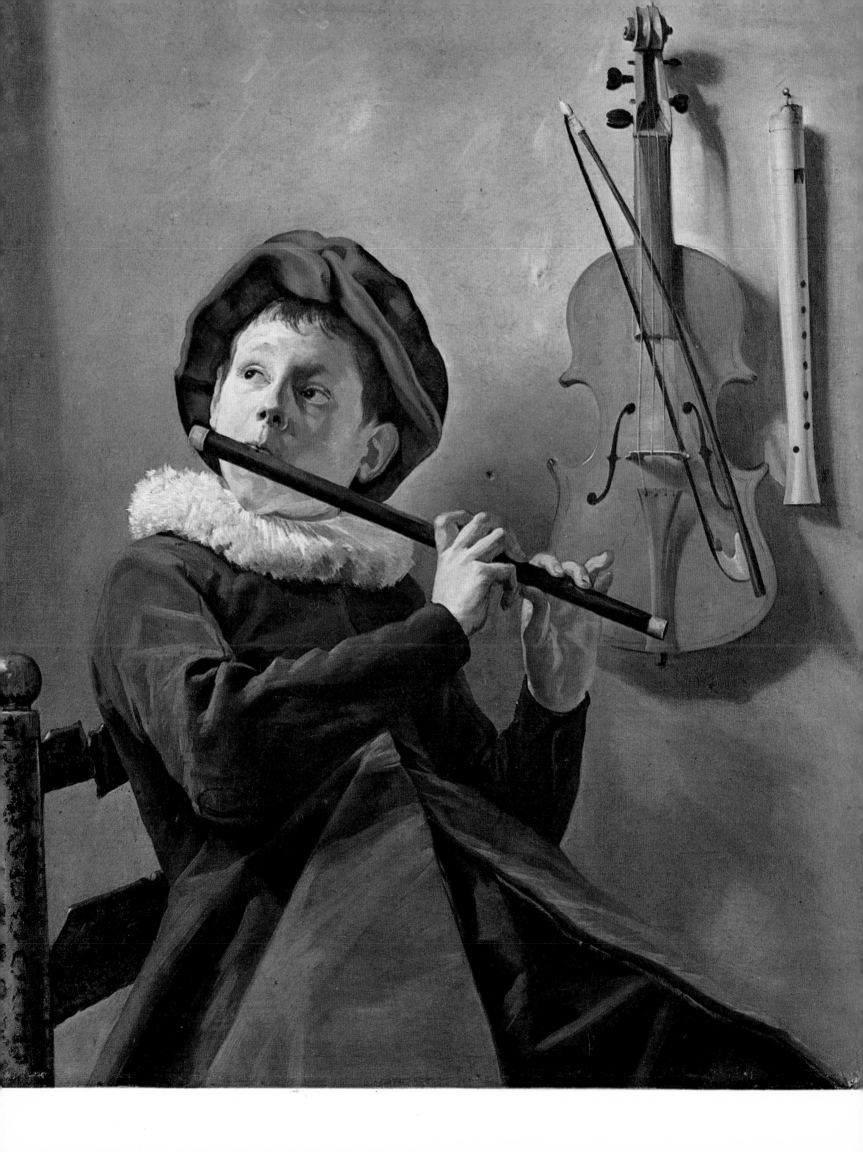

Opposite **Leyster:** *The Flute Player*, 73 × 62cm, c.1630

Judith Leyster was probably a pupil of Frans Hals in Haarlem, and she married the genre painter Jan Miense Molenaer in 1636, who is likewise said to have been associated with Hals. It is therefore not surprising that stylistic sources for this picture have been found in Hals' group portraits of the early 1620s. The picture is, however, stamped with a uniqueness which would make it hard to mistake for a Hals: instead of flamboyant brushstroke, there is a smoothness of touch, and each item is carefully modelled so as to give it an air of solidity. It may be that this painting, like so many depictions of musicians, represents the sense of hearing.

Sweerts: *Youths in a Tavern*, 100 × 95cm, c.1658

while his spectators listen casually, or wander away. There is an interesting juxtaposition of country folk, seen here in their natural surroundings, and a small group of well dressed city dwellers who stand in the middle distance. They act as witnesses to the fascination that the countryside must have held for the inhabitants of Dutch towns, which helps to account for the popularity of such bucolic scenes.

Parallel to the development of peasant scenes is a different tradition of more genteel genre painting. Particularly favoured early in the century, because of the ever present military threat, and the consequent proliferation of private militia companies, were barrack-room scenes. The chief practitioners of this type of painting were Willem Buytewech, Willem Duyster, and Pieter Codde. Their paintings generally show small groups of elegantly dressed men and women banqueting, playing cards or backgammon, and often indulging in flirtation. Such pictures are nearly always littered with reminders of the transience of human life, and are to be construed as warnings against licentious behaviour, rather than as celebrations of sensual enjoyment, even if they were bought because of their joyful, erotic appeal.

Michiel Sweerts' charming *Youths in a Tavern* is more than an amusing exchange between four young men; it is also a warning on how youth imitates old age. These boys, with their pompous poses, pipes and tankards, are undoubtedly aping the bad habits of their elders. The same theme often occurs in Jan Steen's painting, which usually has some didactic element beneath the comic anecdote. His numerous treatments of the subject of the doctor's visit belong to this theme, since they serve as a reminder of the price a young

Right **Steen:** *The Love-Sick Woman*, 61 × 52cm, 1660–70

Jan Steen painted several works on the theme of the doctor's visit to a young woman, and they all contain an element of farce. He frequently drew upon theatrical figures as sources for his compositions, and the doctor with his outdated and melancholy black costume is a stock figure of fun. Of course, he will never cure the malady from which the young woman suffers, which is the sickness of love. As if to underline the point, a statuette of a cupid above the door aims his arrows at the participants in the little drama below, and above the bed hangs a painting of some lascivious scene. The skill with which the sumptuous carpet and the small still-life of the peeled lemon, symbolic of deception, have been rendered is evidence of Steen's debt to the Leiden school of fine painters.

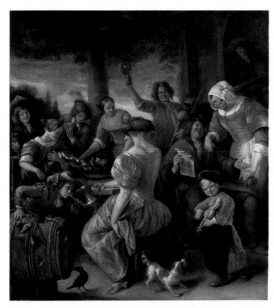

Steen: *The Basket of Cats*, 150 × 148cm, 1670s

woman often has to pay for the pleasures of love. Steen was a varied and prolific artist, and an acute observer of the manners of all sections of society. His talents extended to roistering tavern scenes (drawn, no doubt from his own experience as a tavern owner), sober religious works, and polite Watteau-esque *fêtes galantes*. A strong sense of farce characterizes his prodigious output. In *The Courtyard* the artist has included his own self-portrait — he is the man on

Steen: *The Courtyard*, 68 × 58cm, *c*.1660

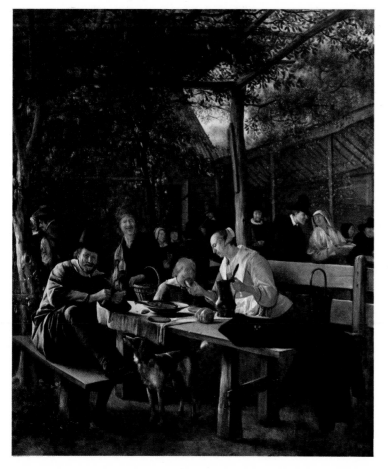

the left holding the pickled herring — among the rest of the drinkers. The ridiculous aspect of this figure demonstrates that Steen was not above self-satire. Steen was a native of Leiden, a town associated with a tradition of fine, detailed painting, best exemplified in the work of Gerard Dou. Steen also exhibits a love of detail, although of a rather different nature. His method of composition is cumulative, and he crowds his canvases with figures and incident, but the handling of paint is always freer and less meticulous than that of his Leiden contemporaries. This may reflect the influence of the Haarlem painters, since Steen spent his most productive years during the 1660s in that town. Stylistically, his work is eclectic, but one finds towards the end of his career the increasing dominance of a rather French, eighteenth-century manner, and more elegance and glossiness of paint surface.

Gabriel Metsu was a fellow Leiden painter, and a pupil of Gerard Dou, although much of his work was executed in

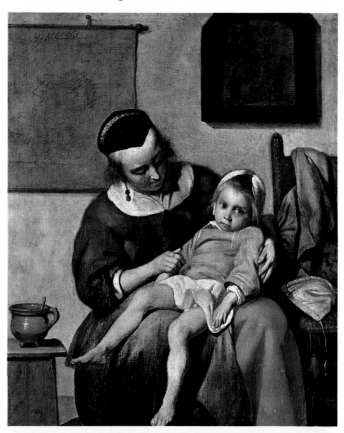

Above **Metsu:** *The Sick Child*, 33·2 × 27·2cm, *c*.1660

The subject matter of this painting is typical of Gabriel Metsu, who frequently depicted figures set in domestic interiors, although they are generally more luxurious than this plain dwelling. The composition of mother and child inevitably carries strong associations with Pietà paintings, and invests the work with a quiet solemnity and dignity. The religious reference is also reflected in the crucifixion scene hanging on the wall to the right of the mother's head. Whether the child is really ill, or merely subject to a fit of lassitude, is a matter of personal interpretation.

Amsterdam. His speciality was the depiction of domestic interiors, such as ladies in boudoirs combing their hair, and servants preparing meals. *The Sick Child* is an excellent example of his delicacy of touch. Close in style to Metsu is Gerard Ter Borch, who worked for most of his life in the comparative isolation of Deventer, in the North of Holland. He produced a number of sophisticated interiors, whose cosmopolitan flavour reflects a knowledge of art in Haarlem

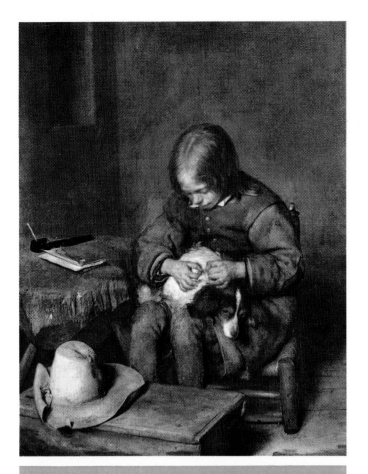

Below **Ter Borch:** *Brothel Scene*, 71 × 73cm, and detail pages 44–5, 1654–5

This painting presents an interesting case study in how successive generations can interpret paintings according to their own preconceptions, so that the meaning a work had for its original viewers is forgotten. Goethe writing in 1809 describes the picture thus: 'The noble knightly father sits cross-legged and appears to be admonishing his daughter standing before him. The latter, a magnificent figure in a white satin dress which hangs in abundant folds, is seen only from behind, but her whole attitude seems to indicate that she is restraining herself. One can see from the expression and bearing of the father, that the admonition is neither violent nor shaming, and as for the mother, she seems to hide a slight embarrassment by looking into a glass of wine she is sipping.' Goethe was no doubt led to this view by the title *L'Instruction Paternelle*, which had been added to the engraved version of the work by an eighteenth-century printer, and which was entirely in keeping with the rather sentimental moralizing tone of eighteenth-century painting. When cleaning revealed traces of a coin in the hand of the man, a more plausible interpretation of the work as a brothel scene emerged. The man appears to be propositioning the woman, who, with a delicacy characteristic of Ter Borch, has her face turned away from us. The woman sipping wine is evidently the procuress.

Above **Ter Borch:** *Boy Removing Fleas from his Dog*, 35 × 27cm, 1650–60

It is appropriate that Gerard Ter Borch, whose paintings display such virtuosity in the suggestion of texture, should be represented by this painting, which has been seen as a personification of the sense of touch. Paintings of single figures to symbolize one of the five senses were very common in seventeenth-century Holland. But this painting is more than just an emblem; it is also a perceptive study in expression. The melancholy eyes of the dog makes an amusing contrast with the look of rapt concentration on the face of his master. The subdued tones of the background and the boy's clothes serve to highlight the whiteness of the dog's coat and dexterity of the hands as they search through the fur.

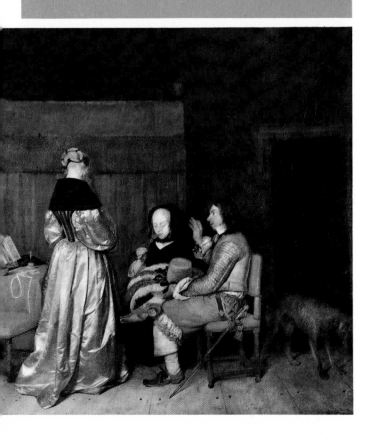

and Amsterdam, which he gained by travelling to those towns before finally settling in Deventer. Ter Borch began, like so many genre painters, as a specialist in barrack room scenes, but soon turned to portraiture, for which he gained some renown. His *Helena von Schalke as a Child* has something of the flavour of Velasquez about it, and it has been suggested that Ter Borch may actually have visited Spain. His particular talent was for rendering surface textures, like the shine of the dress in the *Brothel Scene*, and of those in *The Concert*, and the superbly painted fur in *Boy Removing Fleas from his Dog*. Nicolaes Maes is another artist who worked in the seclusion of a provincial town, in his case, Dordrecht. Maes started out as a pupil of Rembrandt, and his early paintings show evidence of his master's style. The

OVERLEAF **Ter Borch:** *Brothel Scene* (detail)

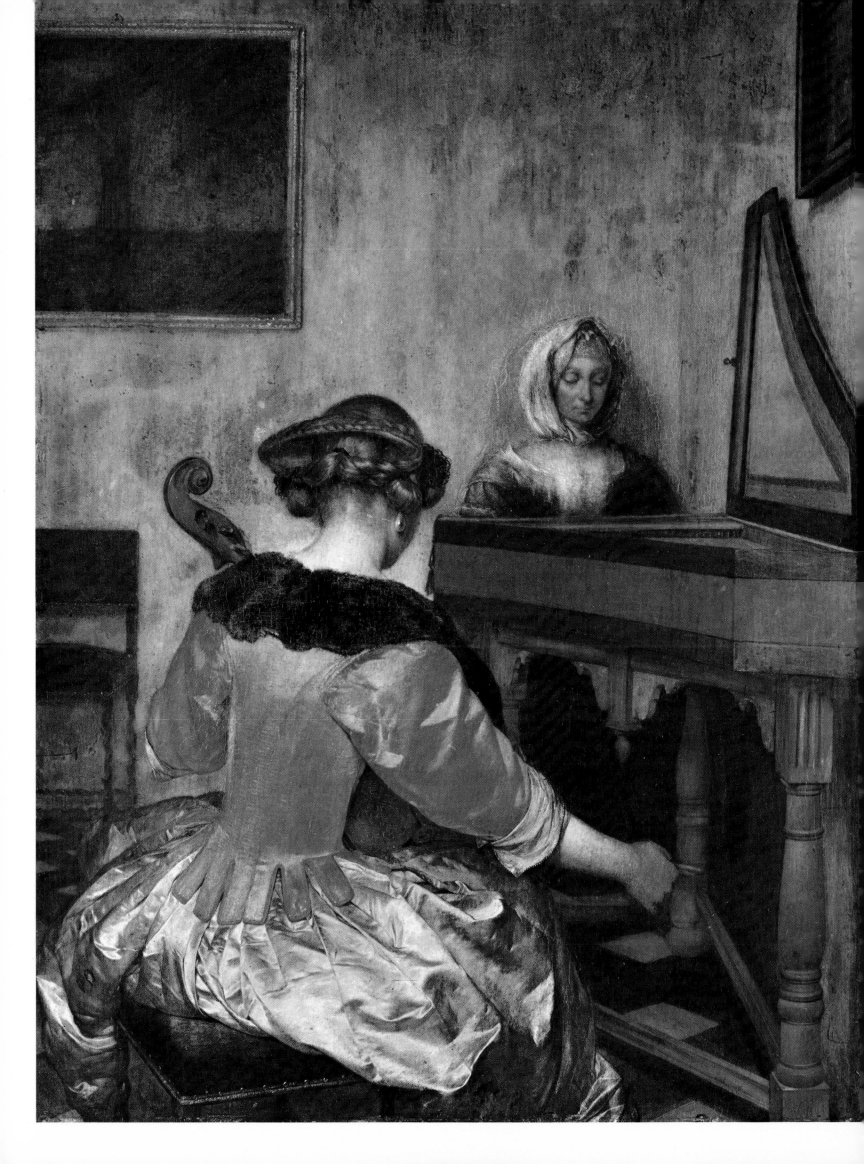

soft, wrinkled skin of the old woman in *The Blessing* is highly reminiscent of Rembrandt's studies of old people in Leiden. The picture is most unlike Rembrandt, however, in its irreverent humour: the pious old woman is concentrating so hard on saying grace that she is quite oblivious to the cat attempting to steal her meal. Maes' later works are closer in

feeling to the paintings of the school of Delft, and display a pronounced interest in perspective.

The quiet interior view is most frequently associated with the Delft painters, Pieter de Hooch and Johannes Vermeer. Their pictures provide an interesting contrast with those of Steen, where the composition is loosely woven around numerous anecdotal details. In the works of these Delft painters, it is the formal aspects of painting which count. With both de Hooch and Vermeer at their best, one feels that the precise disposition of objects within the picture space has been given careful consideration, and that there is no superfluity. Sparsely furnished Dutch homes, with their whitewashed walls relieved occasionally by the rectangular form of a painting and by flagstone floors, provided the painter with an excellent opportunity to experiment with form, light, and perspective. There has long been controversy over which painter of the two originated this type of interior. Both were resident in Delft in the later 1650s, but the fact that it is hard to ascribe definite dates to most of their paintings somewhat blurs the issue. In any case, it is highly likely that de Hooch and Vermeer owed their skill in manipulating perspective not to each other, but to the Delft artist Carel Fabritius whose short career witnessed experiments with peep boxes and the camera obscura.

Pieter de Hooch was born in Rotterdam, but by 1654 had moved to neighbouring town of Delft, where he painted his most pleasing works before his departure to Amsterdam, sometime after 1660. *The Pantry*, which probably dates from de Hooch's Delft years, shows the artist at the height of his powers as a delineator of the Dutch interior. Similar in mood and composition is the *Mother by a Cradle*, although the tones are darker and warmer than those of *The Pantry*, and anticipate the colour schemes of de Hooch's Amsterdam works. *A Woman and her Maid in a Courtyard* transfers a

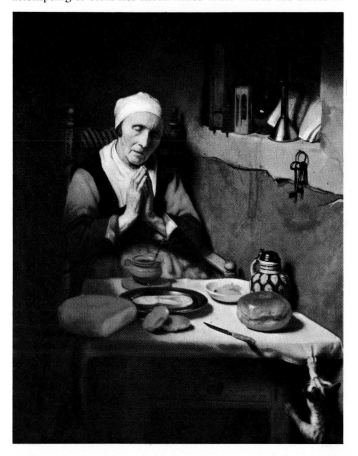

ABOVE **Maes:** *The Blessing*, 134 × 113cm, c.1655

de Hooch: *The Pantry*, 65 × 60·5cm, c.1660

The Pantry is an intriguing painting in which De Hooch combines the charming vignette of a mother handing a jug to an eager small girl, and an experiment in space and recession. Views through open windows and doors are a hallmark of De Hooch's art, often giving rise to observations of reflected light, and contrasts between shadowy interiors and the brilliantly lit streets outside. The elaborate space construction in his paintings brings to mind the popularity of peep boxes, in which the sides were painted so as to give the illusion of a furnished room, with two holes left for the spectator's eyes. The Delft artist, Carel Fabritius, was particularly adept at such tricks of perspective, and it has been suggested that De Hooch may have learnt the skill from him. Usually De Hooch's surfaces are particularly smooth, but areas in this painting, for instance the girl's bonnet, are richly encrusted to give a convincing effect of relief.

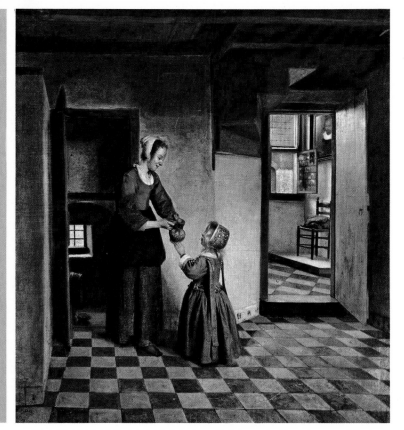

OPPOSITE **Ter Borch:** *The Concert*, 56 × 44cm, c.1675

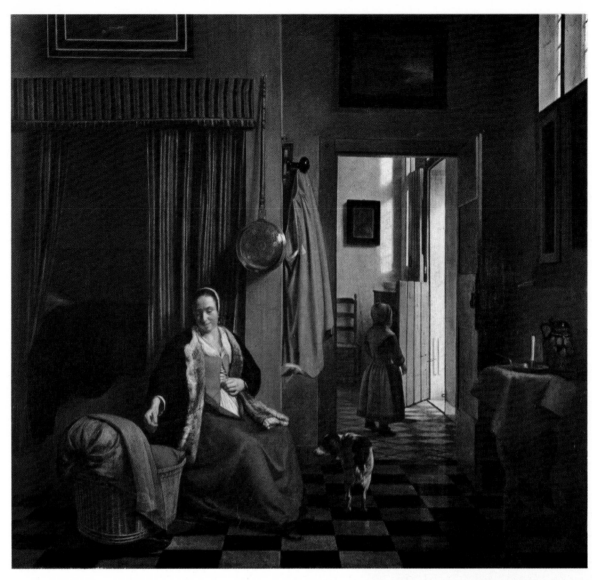

simple genre incident to outdoors, and includes a well observed cold, wintry sky. Even in this open air scene, however, we get the impression of limited space, partitioned by walls or gates, rather than of any expanse. This work was certainly painted in Delft, as it incorporates a fragment of the old town wall in the background. After his move to Amsterdam, de Hooch's art became more mannered, and lost the freshness of his Delft period. This shift of style forms a parallel to that of Jan Steen, and was partly due to a new predilection among patrons for ornate Louis XIV furnishings and dress.

Vermeer made no such move away from Delft, where he remained his entire life. The details of his life are obscure, and the number of works that can definitely be ascribed to him is small. There are no more than about forty authenticated Vermeers. The task of sorting the genuine from the dubious acquired an added urgency following the discovery, just after the war, of a number of forgeries by a living Dutch artist, Han van Meegeren, which had fooled several eminent scholars. Vermeer began by painting religious and historical scenes. His earliest pictures still present problems of authenticity, and the earliest Vermeer of which we can be certain is the Dresden *Procuress* of 1656. It is a painting which reflects the work of the Utrecht school of Caravaggists in treatment, and the subject is relatively commonplace. Most of Vermeer's works, however, stand

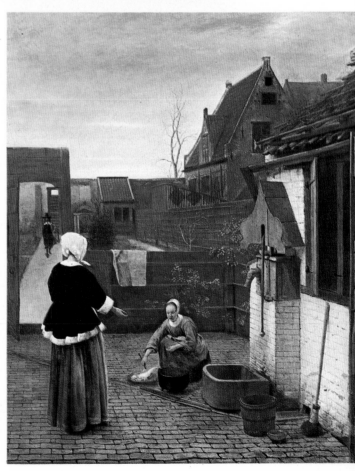

de Hooch: *A Woman and her Maid in a Courtyard*, 73·7 × 62·6cm, 1658

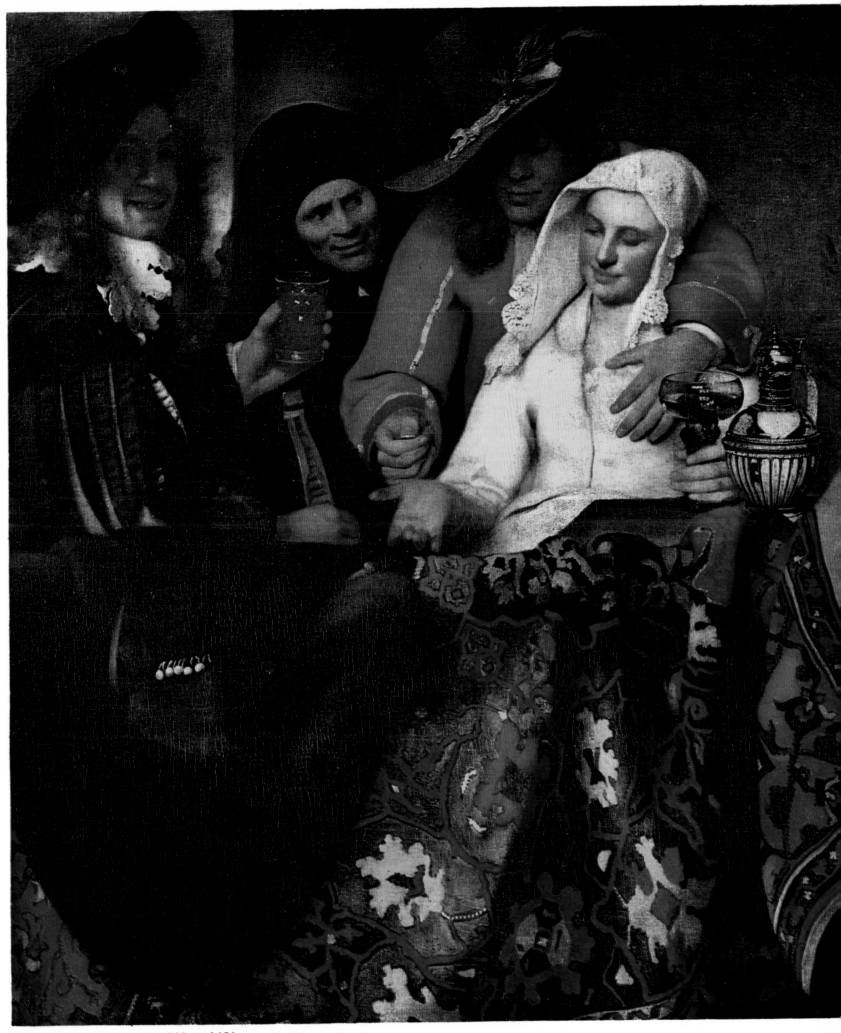

Vermeer: *The Procuress*, 143 × 130cm, 1656

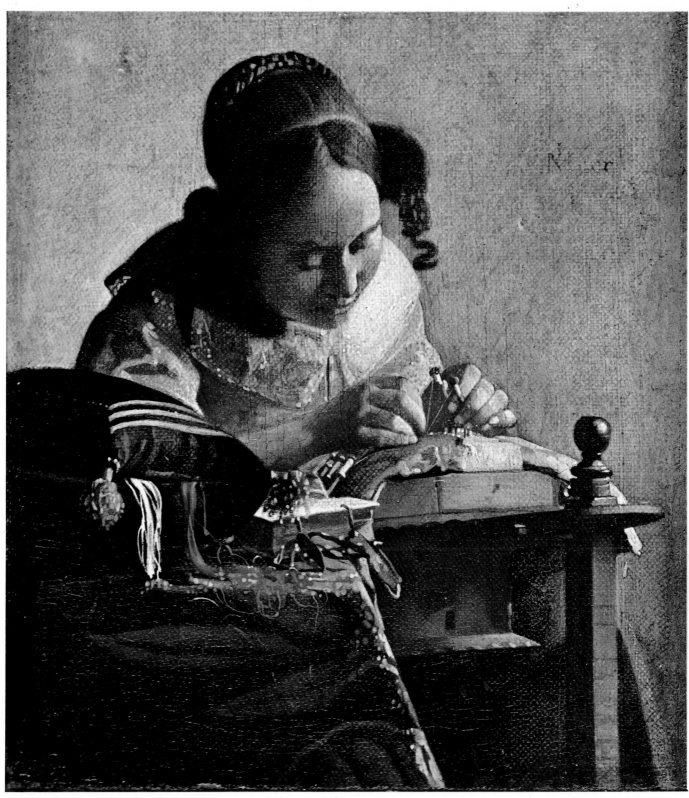

Vermeer: *The Lacemaker,* 24 × 21cm, 1665–8

slightly apart from the bulk of Dutch genre paintings, lacking their densely packed symbolism, and conveying a sense of serenity which is unparalleled in the pictures produced by his contemporaries. In *Maidservant Pouring Milk* and *The Lacemaker* a simple domestic action is frozen and monument-alized, and is sufficient matter in itself to constitute a painting.

Maidservant Pouring Milk offers no release from the confined box-like space through a door or aperture. All attention is focused on the gravity of the woman performing

her task, and the fall of light from a window onto the objects in the room. The same observation of the effect of directional light may also be seen in *Interior with a Gentleman and a Young Woman with a Wineglass.* Here there is an added interest because of the refraction through the leaded glass panels set in the window, which, paradoxically, prevent our seeing the world outside. A similar ingenious use of glass panes can also be seen in the *Interior with a Girl at a Window Reading a Letter,* where we are allowed to catch a glimpse of

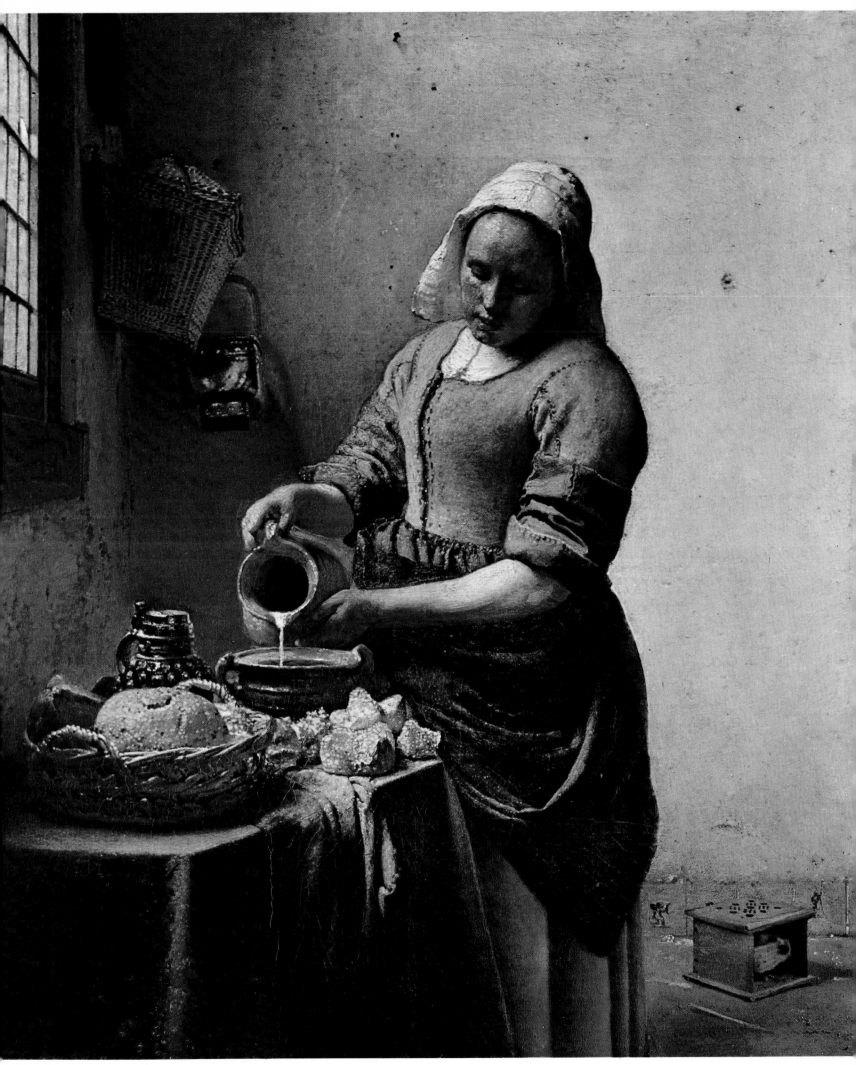

meer: *Maidservant Pouring Milk*, 45·5 × 41cm, 1660–5

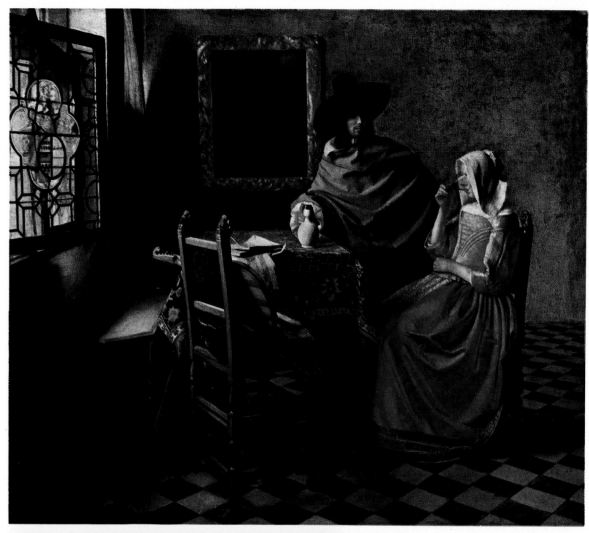

Vermeer: *Interior with a Gentleman and a Young Woman with a Wineglass,* 65 × 77cm, 1665

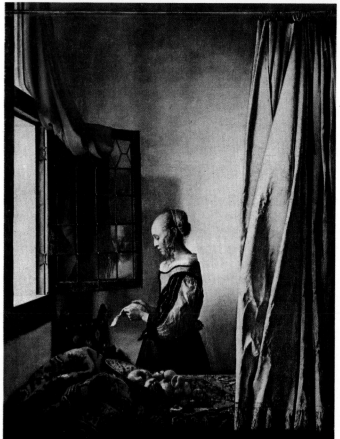

the girl's features as they are mirrored, in slightly distorted form, in the window. There is no straightforward narrative in these enigmatic paintings. The exact relationship of the man to the girl is uncertain, and the contents of the girl's letter may only be guessed.

Vermeer's later works sometimes possess an allegorical significance. This certainly is true of *Woman Weighing Gold, An Allegory of Painting,* and *Young Woman at a Clavichord.* The large painting in the background of this third work shows a cupid holding up a blank playing card. The painting may have been a real one from Vermeer's own collection, but the cupid motif is of crucial importance to the entire picture. It may be traced back to emblem books — popular works widely used by artists, which combine engravings and rhymes — where the image exalts faithfulness to one lover in preference to attachment to many. This interpretation gains in credibility when one considers that this painting was probably intended as a pendant to Vermeer's *Young Woman Seated at a Virginal,* which shows a painting by van Baburen entitled *The Procuress* hanging in the background. The pair, when hung together, could thus have been viewed as sacred and profane love.

Vermeer also painted two superb miniature landscapes, *A View of Delft,* where a fleeting moment is captured in the scurry of clouds, and *The Little Street.* This last painting

Vermeer: *Interior with a Girl at a Window Reading a Letter,* 83 × 64·5cm, *c.*1658

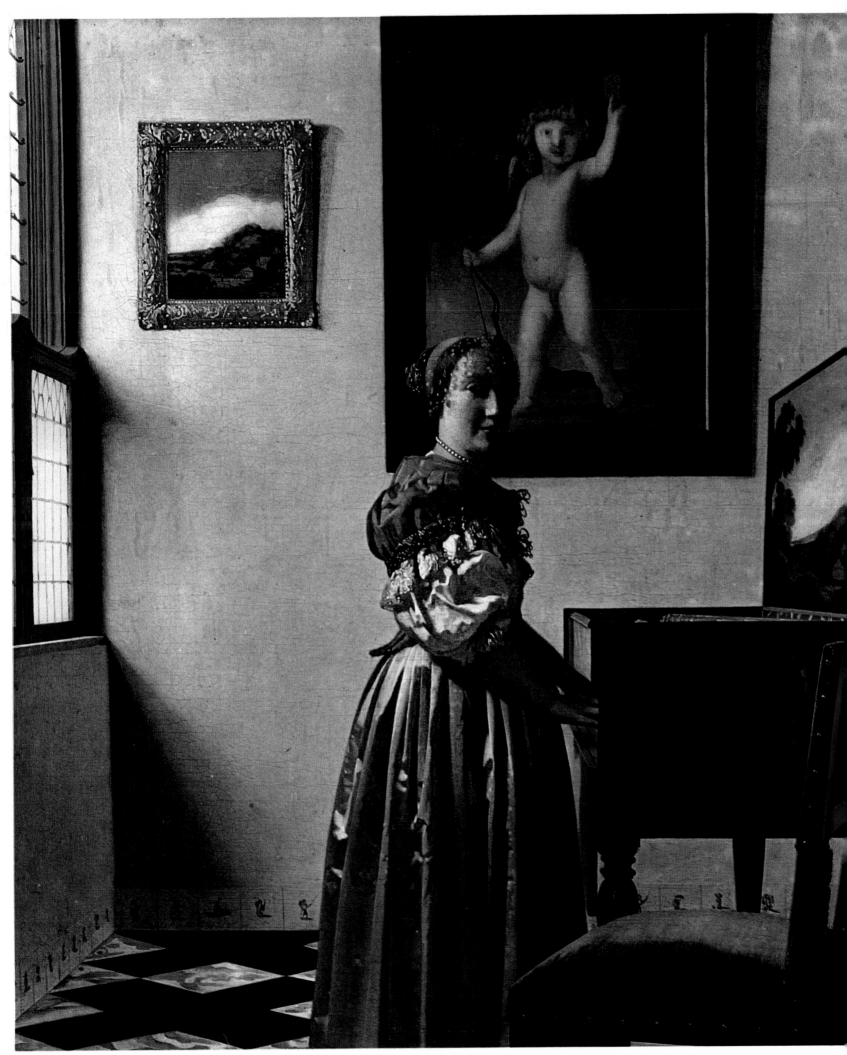

Vermeer: *Young Woman at a Clavichord*, 51·7 × 45·2cm, 1670–5

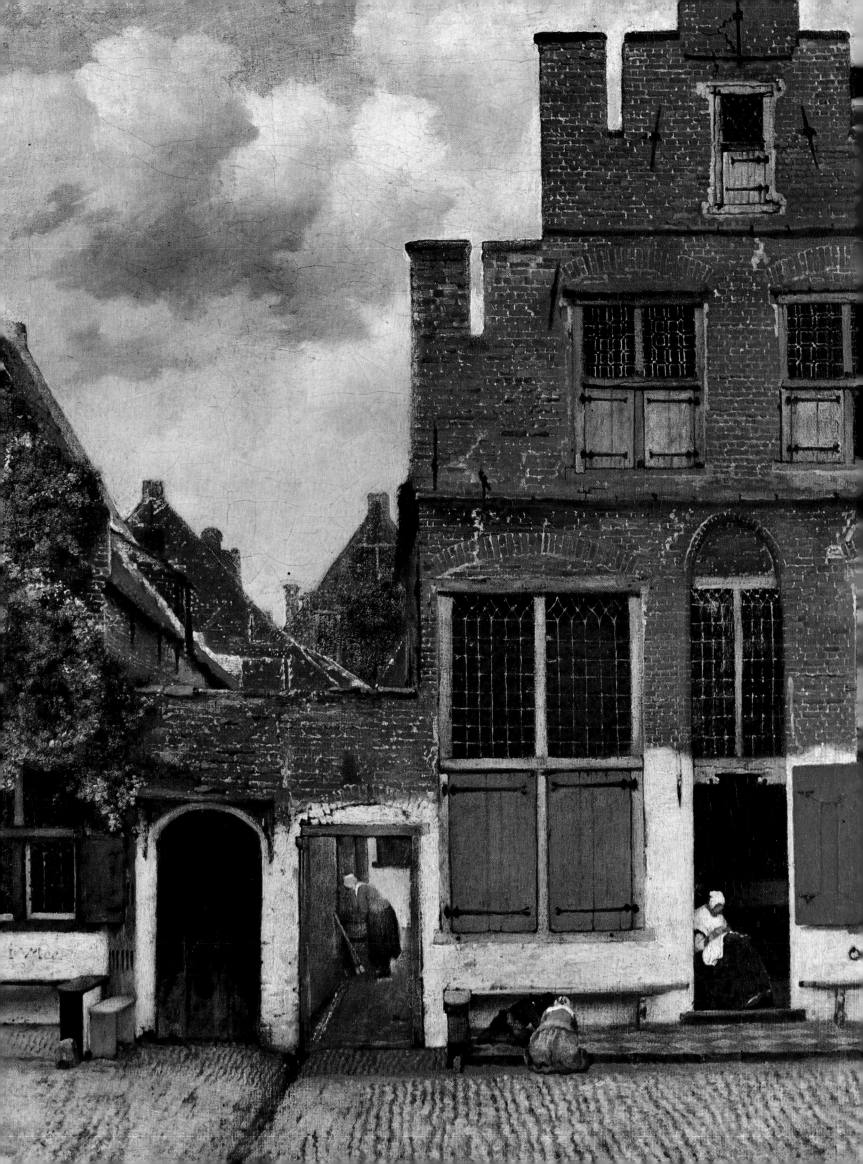

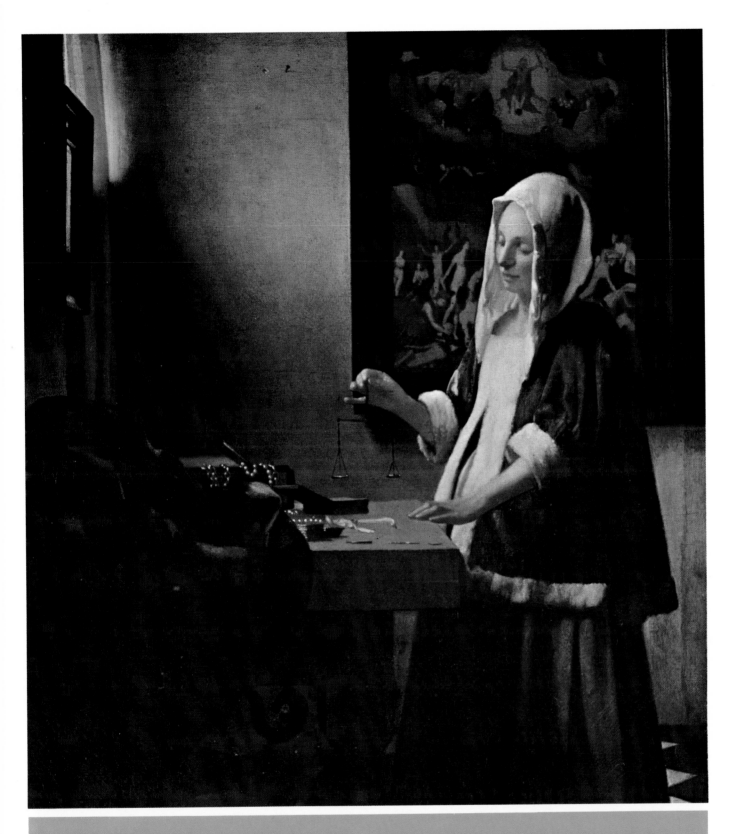

Vermeer: *Woman Weighing Gold*, 42·5 × 38cm, c.1665

Women engaged in domestic activities, such as reading letters, or playing the clavichord, either alone, or in the company of their maid, are the mainstay of Vermeer's art. Superficially, this picture looks like one of these simple genre scenes, yet closer inspection reveals unmistakable hints of allegory. Vermeer often uses the device of a picture within a picture to expand the meaning of his works. Although the painting hanging on the back wall has not been identified with any known work, it is obviously a Last Judgement subject, showing God in majesty above the mass of humanity. The parallel between the weighing of souls in the background, and the weighing of gold (or, perhaps pearls) in the foreground, adds a symbolic significance to the woman's action. Further emphasis is given to the weighing ritual by the fact that the scales are the central point in the composition.

The painting is rather dark in tonality, with just a glimmer of light entering the room from a high window on the left. The soft gleam of the gold, and the shine of the pearls stands out in this gloomy atmosphere.

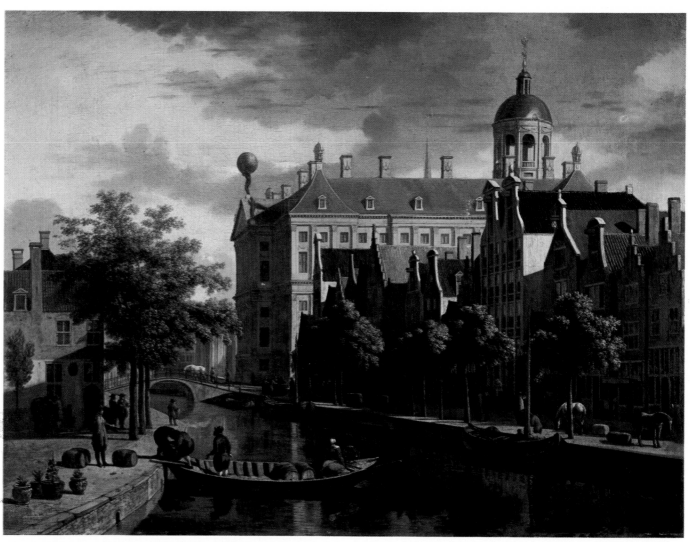

Gerrit Berckheyde: *The Flower Market, Amsterdam,* 45 × 61 cm

reflects the Dutch interest in the depiction of townscape. Views of towns make their appearance in Dutch art in the 1650s and 1660s. They echo a shift of interest in landscape painting away from the obsession with tonality which dominated the 1630s and 1640s, and towards a more emphatic, structured way of painting. The roots of townscape lie in the paintings of Flemish artists such as van Eyck, where miniature town views are often glimpsed through doors and windows. But the most immediate predecessors of this kind of painting are Vermeer's *View of Delft* and Fabritius's *View of Delft,* both of which show a panoramic picture of the town. By contrast, Vermeer's *Little Street* shows only a tiny part of a town, the façade of one house. Although there is an obvious interest here in the light cast by the dull sky, the main concentration is focused on the surface pattern formed by the bricks, which are whitewashed to just above the door.

Gerrit Berckheyde is representative of the generation of artists who specialized in painting the streets, canals, and squares of Dutch towns. His *Flower Market in Amsterdam* is a fine example of the marriage between architecture and the concerns of landscape, such as reflections in water and the movement of clouds, which this branch of painting could encompass. Instead of showing the new town hall, the pride and joy of Amsterdam, from the front, Berckheyde has

viewed it from the side, so that it does not dominate the row of attractive houses in the foreground, and thereby destroy the balance of the work.

Berckheyde's painting is far looser in handling than the meticulously delineated views of church interiors that were so popular in Holland. The first artist to paint the stark Dutch interior, as opposed to the more fanciful decorated Flemish church, was Pieter Saenredam. Saenredam was a Haarlem artist, and it is proof of the high regard that the Dutch had for the genre that he was actually able to make a living from painting only church interiors. Because Dutch churches were bereft of all wall painting and ornament, artists like Saenredam could concentrate on the bare bones of architectural construction and capture the beauty of Gothic arches receding into space. Such subjects afforded great scope for experiments in perspective: Saenredam's *Interior of St. Odulph at Assendelft* is largely concerned with this preoccupation, as is his *Interior of St. Bavo at Haarlem.* Yet there is another important dimension to these paintings, that of an assertion of faith. Emmanuel de Witte's earliest church interior was encased in a frame with shutters, which had a still life painted on the outside. The idea was that the viewer could turn from the earthly pleasures, represented by the flowers and fruit, to join an attentive congregation meditating on the life to come. Just as a moral

variably inhabited by figures. Landscape is usually humanized, and the presence of man in nature an established fact. In general, nature is not represented as a vast elemental force; the little armies of herdsmen, hunters and travellers who journey through the landscape endow it with a familiar domesticity. The Mannerist painter Carel van Mander writing about landscape advised artists: 'Make the countryside or the town full of activity; people should be doing things in their houses and others should stroll on the roads.' The Dutch painter of the seventeenth century brought a fresh view of nature to art, and developed pure landscape,

LEFT **Saenredam:** *The Interior of St. Bavo at Haarlem*, 95·5 × 57cm, 1636

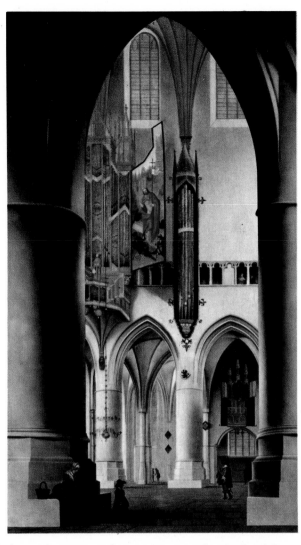

BELOW **Houckgeest:** *The Interior of the Old Church at Delft*, 49 × 41cm, 1650s

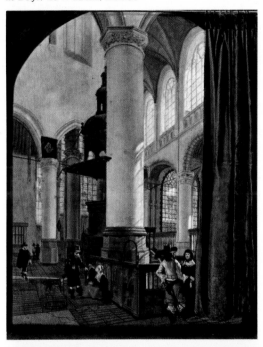

could always be conveyed in a painting of everyday life, so the message of eternal life through the church could be contained in the church interior. The frequent inclusion of tombs of illustrious men serves as a reminder of the transient nature of human glory.

Several Dutch interiors show landscape paintings hanging on the wall, surrounded by black or gold frames. Though rarely identifiable as the work of any known master, they testify to the widespread enjoyment of landscape paintings. Few were done on commission, and most were produced for the open market, and were probably very cheap. There is great diversity in what was actually painted, ranging from panoramas and beach scenes, to forests and winter pictures, but Dutch seventeenth-century landscape is almost in-

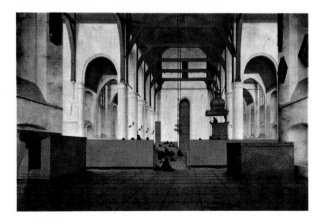

Left **Saenredam:** *The Interior of St. Odulph at Assendelft*, 50 × 76cm, 1649

Pieter Saenredam was a Haarlem artist, who recorded the architecture of his surroundings, especially Romanesque and Gothic churches, with painstaking exactitude. His work is distinguished from that of his fellow painters of church interiors by a fanatical insistence on the clarity and order inherent in the geometrical arrangement of space. The feeling of precision is particularly evident in this painting, where the main interest is focused on the convergence of the walls towards the nave. It is only at a second glance that we notice the diminutive figures in the pews. Saenredam rarely includes people in his interiors for their anecdotal interest: they are usually only present as a reminder of both scale, and the fact that the building has a function. In this respect, Saenredam differs from other painters of church interiors, such as de Witte, who frequently depicts men and women in conversation, and so humanizes the architecture. There is, however, an element of autobiography in this painting, as the grave of Saenredam's father is presented in the foreground.

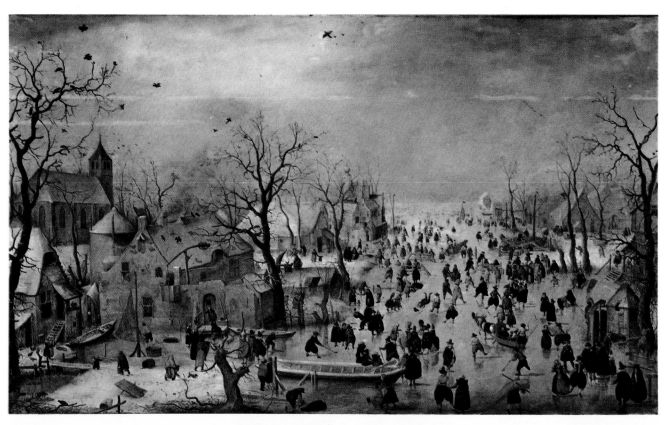

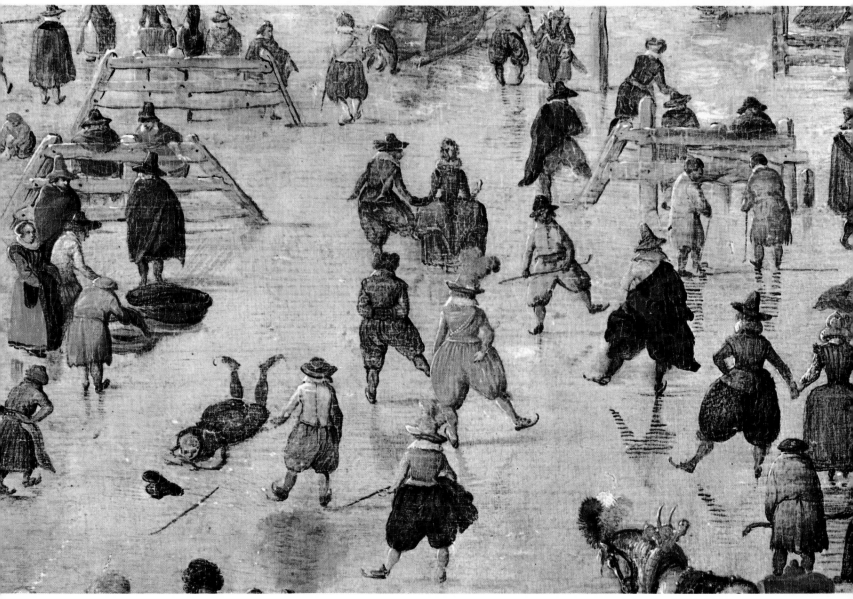

free from biblical or historic incident, into an independent category of painting. Yet naturalism did not always mean artists were accurate in their recording of topography, or in their observation of seasonal changes. Sometimes the features of all four seasons have been included in one picture. The subordination of artistic licence to a truthful representation of nature was not demanded of artists of the period, who felt quite at liberty to change certain aspects of the actual landscape or season to conform to various formulae. Nor did artists paint outdoors. As a rule, landscape paintings were produced in the studio. The painting on the easel of Ostade's *The Painter's Studio* is a landscape. Although quite often painters carried out sketches in the open air, there is little evidence that these were used as preliminary stages in oil painting. Rembrandt, for example, certainly sketched on the spot, and his etchings possess a marked feeling for spontaneous observation. Yet his paintings leave one in no doubt that they are studio productions.

Early in the century, the Mannerist style dominated landscape painting as it did other branches of art. This style is best exemplified in the work of two Flemish *émigrés*, David Vinckboons and Roelandt Savery, and later in that of Abraham Bloemaert which shows giant primeval forests and visions of abundance in nature. One finds the beginnings of a movement towards a more typically Dutch, and naturalistic form of painting in the works of Esaias van de Velde and Hendrick Avercamp, where there is a fresh feeling of space and atmosphere. In this early naturalism, the Flemish heritage is still strongly felt, particularly in the importance attached to minute details, and the rather high colour key. It is significant that the most progressive landscapes painted by these two artists were winter scenes, as these represented a branch of landscape where Dutch artists felt freer to experiment, perhaps because there could be no south European prototypes. Yet it was not long before painters began to react against the type of composition epitomized in

Opposite **Avercamp:** *Winter Landscape,* 77·5 × 132cm, and detail, early 17th century

The winter landscape represents a tradition that is entirely Northern in origin, as opposed to other types of landscape painting that can be traced back to Italian or French models. The most important precedent for this kind of painting is to be found in the work of the Flemish artist, Pieter Bruegel. Hendrick Avercamp's frequent depiction of snow-covered landscape and frozen rivers are close to Bruegel in conception, showing an accumulation of fascinating details against a neutral background, accommodated by a high horizon. In this work, winter is evoked not so much by an observation of weather effects, as by a portrayal of the delights of winter sports, such as skating, playing hockey, and falling over on the slippery ice. Avercamp was the first important specialist in winter landscape painting in Holland, living in isolation from main artistic developments, in the small town of Kampen in the north of the country.

Below **Savery:** *Landscape with Birds,* 54 × 108cm, and detail overleaf, c.1620

Roelandt Savery was, in fact, Flemish by birth. He later emigrated to Holland, and was settled in Utrecht by 1619. He had spent some time at the turn of the century in the service of the Emperor Rudolph at Prague, so it is appropriate that he should be represented by a painting from that city. Savery is chiefly remembered as an artist of animals, birds and flowers, although he also painted a number of landscapes based on Tyrolean views, which were greatly admired by Dutch painters. The Emperor Rudolph possessed an extensive menagerie of exotic animals, several of which found their way into Savery's paintings. It is even said that he was able to draw the now extinct dodo from the life.

This painting is highly characteristic of Savery; it represents a fantasy landscape populated by birds, and the delicate blue hues, and finely painted details testify to his Flemish origins.

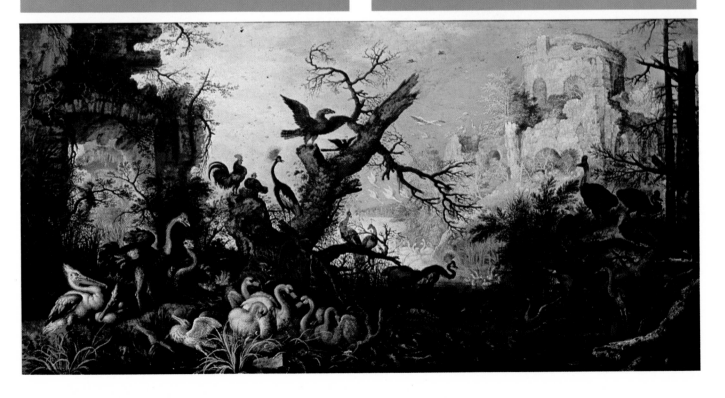

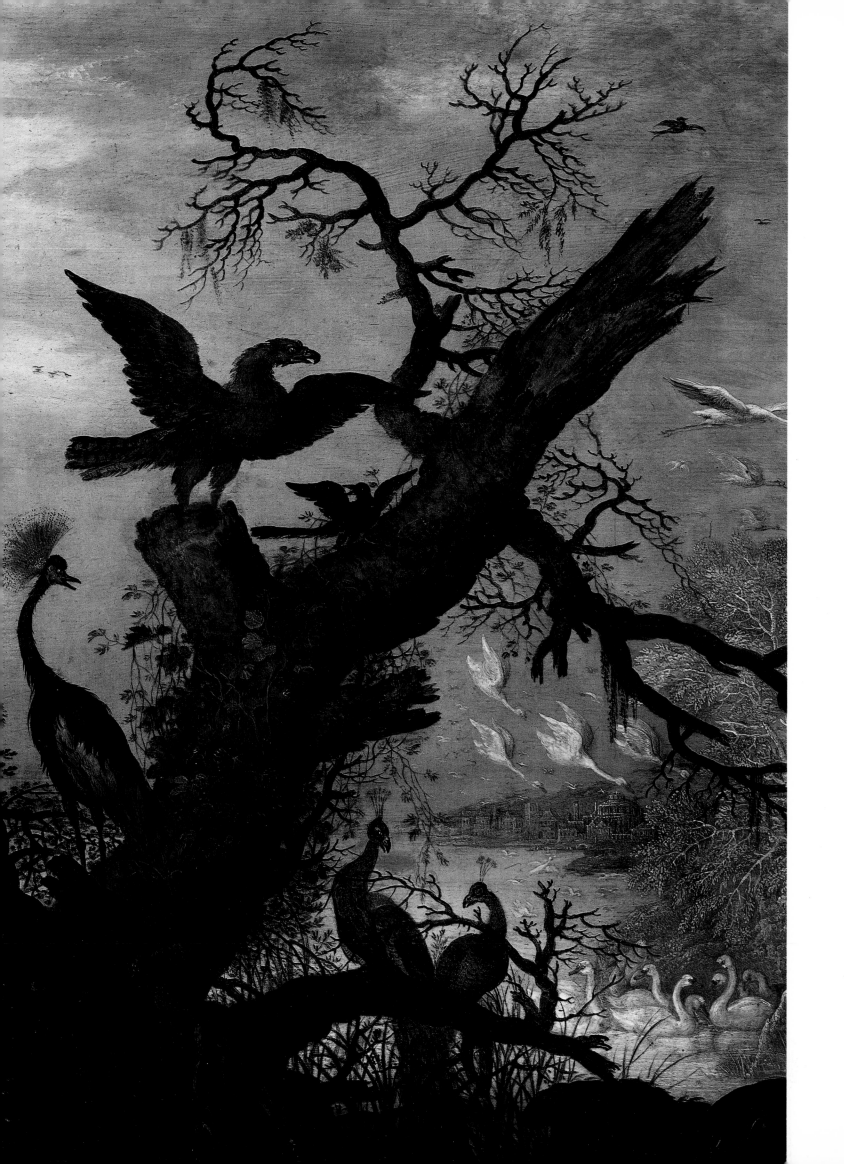

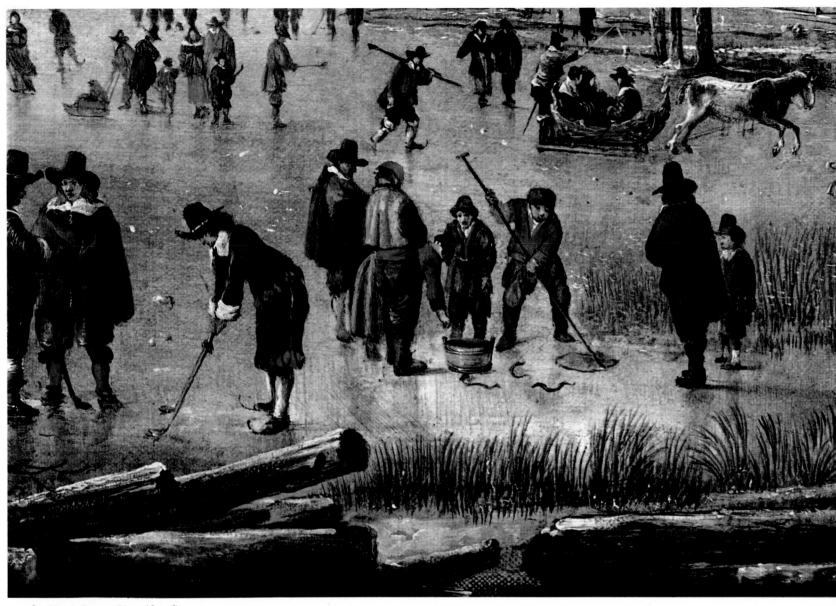

van der Neer: *Frozen River* (detail)

Avercamp's *Winter Landscape* with its lack of coherence and its fussiness. Around 1630 a new mood began to develop, in which an observation of nature took precedence over the depiction of human details in landscape. A comparison between the Avercamp picture and Aert van der Neer's *Frozen River*, which both depict winter skating scenes, highlights this development. The horizon is lower, and accommodates fewer incidents in the van der Neer, and more attention is given to weather effects, and the cold quality of light on a winter morning. This period of landscape painting, which lasted until the middle of the century, has been called the 'tonal phase', and it is Jan van Goyen who is normally cited as the most eloquent representative of the movement.

Van Goyen was taught by a variety of masters, the most influential of whom was Esaias van de Velde, whose rich and colourful style finds its way into van Goyen's early works. During the 1620s van Goyen began to cool his palette and paint river scenes in low-key tonality. This trend in his work culminated in the 1630s and 1640s, when his paint-

OPPOSITE **Savery:** *Landscape with Birds* (detail)

ings became completely monochromatic. *The Well* is an example of this phase. The execution is rapid, the brush-stroke broken, and the whole painting conveys a tremendous sense of airiness. The simple compositional format, based on a receding diagonal, and the lack of clutter on the ground bring the sky, with its scudding clouds, into greater

Pages 62–3. **Van Goyen:** *The Well*, 55 × 80cm, 1633

The Well was painted at the height of Jan van Goyen's monochromatic phase, during the 1630s. All colour has been limited to variations on the tonal scale of brown. There is a happy blend of humanity and landscape. A man and woman operate the well in the foreground, while other peasants go about their daily activities, but anecdote is never allowed to obtrude. Everything is subordinated to the design of the composition, which is based upon a receding diagonal that follows the line of the cottages into the distance. The brushstroke is rapid, and the apparent lack of finish lends the picture an air of freshness.

Jan van Goyen: *Boat on a Calm Sea*, 51 × 66cm

de Molyn: *The Surroundings of a Village*, 55·5 × 66cm, *c*.1625–30

Salomon van Ruysdael: *The Ferryboat*, 99·5 × 133·5cm, 1649

Salomon van Ruysdael: *The Halt at the Inn*,
91 × 136·5cm, 1649

prominence. Pieter de Molyn, who was based at Haarlem, shares with van Goyen an interest in the motif of sand dunes beneath a vast sky. His *Surroundings of a Village* captures well the bleak, open quality of the Dutch countryside. Although de Molyn is generally believed to have been the first to arrive at the tonal style of painting, he lacked the invention of van Goyen, and his work can sometimes look repetitive.

Salomon van Ruysdael, a fellow Haarlem artist, brought more subtlety to the painting of dunes and rivers. His own

speciality is a calm, lyrical rendering of these subjects, with a restrained use of colour, especially blues and greens, to suggest the evanescence of atmosphere which surrounds river banks. This freshness of colour is particularly notice-able in the Rijksmuseum *Ferryboat*. *The Halt at the Inn* shows Ruysdael moving away from the art of van Goyen, towards a more structured form of painting, with greater emphasis placed on vertical lines and less on diagonals. The gnarled tree to the left of the composition, which acts as a balance to the masses on the right, became a favourite motif of

Salomon van Ruysdael: *The Road in the Dune*, 34·8 × 46·8cm

Salomon's famous nephew, Jacob van Ruisdael. It can be seen in the foreground of his *Jewish Cemetery*, where it is particularly appropriate as a reminder of suffering and the transience of human life.

Painters of Jacob van Ruisdael's generation often added drama to their landscapes by monumentalizing certain features, such as trees, animals, or buildings, sometimes showing them silhouetted against the sky. Philips Wouwerman's *White Horse*, and Paulus Potter's *Horses in Pasture* are good examples of horses used in this way. Adriaen van Ostade's *Landscape with an Oak* also illustrates this tendency. In part, this may be seen as a reaction to the understatement of tonal landscape: it was a means of turning landscape painting into something more grandiose in conception, with greater emphasis on structure than there had been in previous painting, and with strong effects of chiaroscuro. A comparison of the works of Jacob van Ruisdael with those of his uncle demonstrates this shift of interest. Jacob van Ruidael's paintings often evoke a romantic and melancholy mood. He responded to the dark, mysterious side of nature where Salomon had almost sympathy with its light, fleeting quality.

Ruisdael: *The Jewish Cemetery*, 84 × 95cm, after 1670

This is one of two versions of the painting; the other is in Detroit. The dating of neither painting is certain, but they can probably be ascribed to about 1670. Comparison between the two paintings shows the extent to which Ruisdael discarded topographical accuracy in favour of manipulation of motifs to produce heightened dramatic effect. The three graves in the middle distance can still be seen today in the Jewish burial ground at Ouderkerk near Amsterdam; but the surroundings are a romantic invention of the artist. To judge from contemporary drawings, including some by Ruisdael, there were no hills in the background, the trees were smaller, and the impressive ruin was merely a country church. The ruins in the two versions of *The Jewish Cemetery* are not even identical. The most popular interpretation of the two paintings has been as an allegory on the transcience of human life. The tombs, broken trees, ruins and storm clouds evoke a mood of melancholy and decay, relieved by the rainbow and the trees in leaf, both symbols of promise and renewed life.

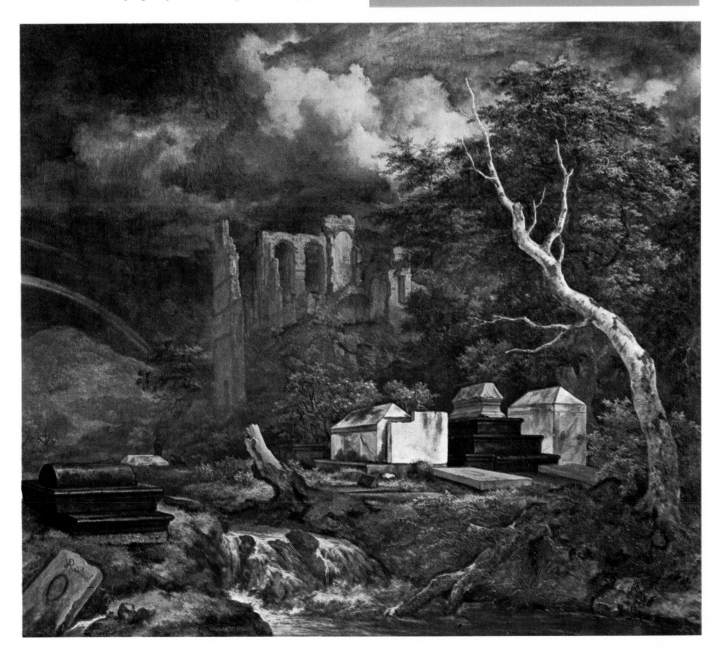

RIGHT **Wouwerman**: *The White Horse*, 43·5 × 38cm, 1660–70

Below **Potter**: *Horses in Pasture*, 23·5 × 30cm, 1649

The date of this work means that Potter was twenty-four when it was painted. He only lived to the age of twenty-eight, but his output was considerable. Despite his evident skill, it is difficult to tell whether Potter attained much recognition in his own lifetime. His animal paintings are characterized by a certain originality. He was able to successfully integrate animals into landscape backgrounds quite often depicting the creatures with an animation that sets them apart from mere animal studies. The two horses in this landscape are aware of their surroundings; the brown horse in the foreground even has an expression of fear of surprise, and it is as if the white horse is watching his fellow, and reacting to him. One may wonder why the horse appears so frightened; perhaps it is due to the imminent storm suggested by the murky atmosphere and massing clouds. Two flying birds, silhouetted against the sky, add to the feeling of menace.

Ruisdael's *Forest of Oaks beside a Lake* contains his favourite motif of trees overhanging water, and the *Large Forest* is another illustration of his love of wooded landscapes. It is estimated that Ruisdael painted at least 140 such subjects. In this latter painting the giant forest of oaks forms a solid mass against the sky, completely dwarfing the tiny figure sitting by the pathway. The pronounced juxtaposition of light and shade over the foreground adds to the sense of mystery and gloom which pervades this work. The weather effects in Ruisdael's paintings have very little to do with nature; it is as though the artist has translated his own inner landscape onto the canvas. *A Jewish Cemetery* is more about a state of mind than about an observation of the outside world.

Ruisdael's most famous pupil, Meyndert Hobbema, followed up some of his favourite subjects. One of these was the

ABOVE **Adriaen van Ostade:** *Landscape with an Oak*, 33·5 × 47·5cm

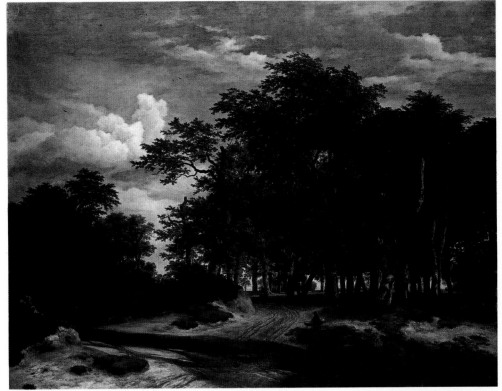

LEFT **Jacob van Ruisdael:** *The Large Forest*, 139·5 × 180cm

BELOW **Jacob van Ruisdael:** *Forest of Oaks beside a Lake*, 114 × 141cm

motif of the watermill, which Ruisdael frequently painted in conjunction with waterfalls. *The Watermill* demonstrates Hobbema's debt to his master. It is, in fact, closer to one of Ruisdael's own drawings than to any study Hobbema may have made of his own accord. Yet plagiarism is no sin in painting. What matters is the end result, and this picture is a delightful combination of the rush of clouds with busy human activity. The effect of the old mill and the dense cluster of trees is extremely picturesque. Looking at the dewy freshness of this picture, it is easy to appreciate Constable's love of Hobbema. Most of Hobbema's best works were painted in the 1660s, although there is no reason to believe the myth that he gave up painting after the age of thirty, having secured a living for himself as wine gauger to the city of Amsterdam. The splendid *Avenue, Middleharnis* of 1689 would appear to contradict this theory, although it is strange that no picture by Hobbema can be confidently said to postdate this work.

Rembrandt's landscapes also have something in common

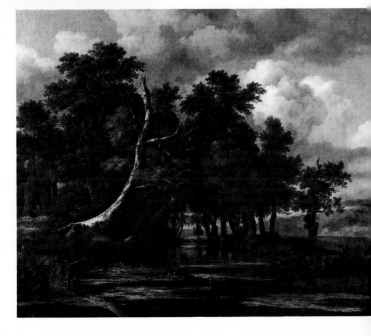

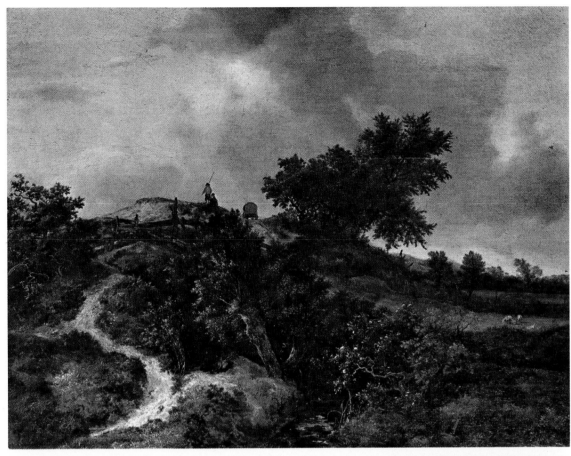

RIGHT **Jacob van Ruis-dael:** *Hill with Trees,* 70 × 91cm

BELOW **Hobbema:** *The Watermill,* 62 × 85·5 cm

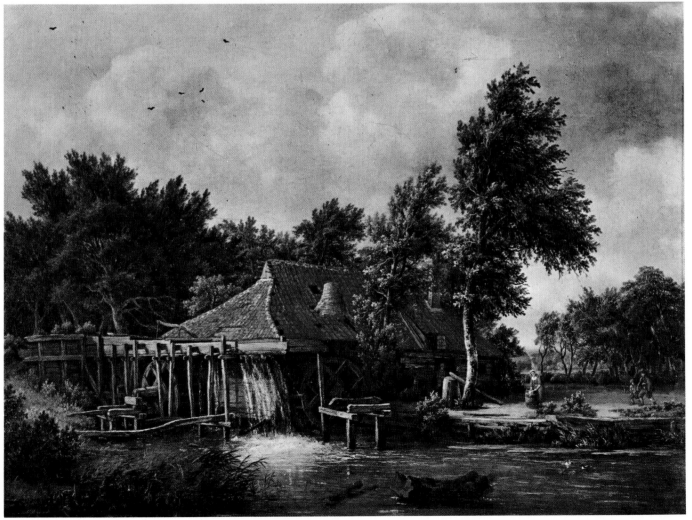

with those of Ruisdael, but it is not, as in the case of Hobbema, a similarity based on borrowed motifs and subject matter, so much as an occasional correspondence of mood. Rembrandt's experiments with landscape painting were concentrated in the period of about 1640–55, and he divided his time between etching and painting. Rather different interpretations of nature emerged from these two media. As an etcher and draughtsman, Rembrandt was a realist, concerned with the close observation of details of the countryside. Yet his paintings are visionary and romantic in character. *Landscape with a Bridge* shows a typical dramatization of a commonplace subject. There is an enormous difference of conception between this painting, and those by tonal painters, who attempted to catch the casual, fleeting moment. Rembrandt deliberately chose times in nature when the elements appeared threatening and sublime, when shafts of light broke through masses of dark clouds.

Philips Koninck is said to have been a pupil of Rembrandt, although whether Rembrandt's landscapes can be seen to have influenced his is debatable. Koninck's speciality was the panoramic view, which can be seen in his *Landscape*. The panorama is a distinctly Dutch phenomenon, since it has such obvious roots in Dutch geography. In Koninck's work, there is usually a roughly equal proportion of land to sky, the horizon being an uninterrupted straight line which bi-

Hobbema: *The Avenue, Middleharnis*, 103·5 × 141cm, 1689

This is one of the best known of Dutch seventeenth-century landscapes, and has become such a visual cliché, that it requires a special effort to regard it with fresh eyes. The painting is comparatively late in Hobbema's career, especially as most of his best work was painted in the 1660s. In contrast to his earlier works, which are usually dominated by masses of luxuriant foliage, reflecting Hobbema's debt to Ruisdael, this work is immensely sophisticated in design. Hobbema has evoked the flatness of the land and the vast expanse of sky that are the essence of the Dutch countryside, through a low horizon and lack of clutter on the canvas. The suggestion of space is reinforced by the way in which the eye is irresistibly drawn into the distance by the diminishing columns of trees. Hobbema avoids a certain rigidity of composition by the fact that the avenue wavers slightly off centre, and the receding plane is balanced by the horizontal grids of the fields.

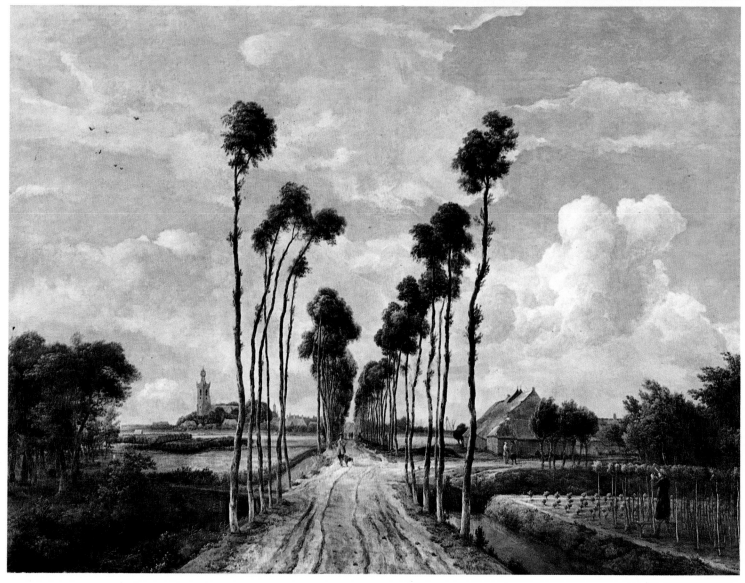

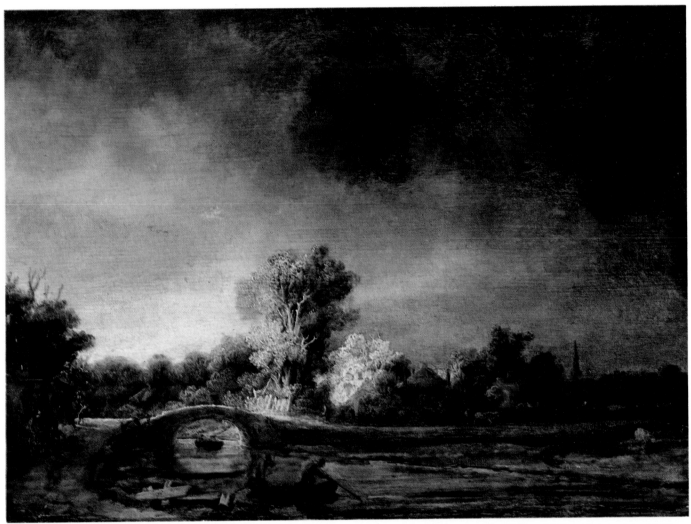

Rembrandt: *Landscape with a Bridge.* 29·5 × 42·5cm, late 1630s

sects the picture. The viewpoint is nearly always high, enabling the spectator to see the effects of shadow and light cast upon the ground by the cloudy sky.

One can trace parallel to the development of a realistic form of landscape based on the Dutch countryside the evolution of a more fanciful, Italianate landscape. Of course, Italianate motifs do occur in the work of painters of the Dutch scene, but they rarely dominate the work. By contrast, there are several artists to whom the landscape of Italy is of paramount importance. The present neglect of these artists is an unfair reflection of their contemporary fame, as they were highly regarded by seventeenth- and eighteenth-century connoisseurs. Cornelis van Poelenburgh is the earliest representative of this type of landscape. He was a native of Utrecht, and, like many of his fellow townsmen, spent several years in Rome as a student. Typical of Poelenburgh is a marked idyllic mood, which is found in pictures of pastoral figures wandering through picturesque ruins. His successful formula was taken up by Nicholaes Berchem, the son of the still life painter Pieter Claesz. Berchem also travelled to Italy in the 1640s, and most of his paintings are Italianate in mood, although not necessarily based on any precise location in the Roman Campagna. They are instantly appealing, with their well painted figures dressed in colourful clothes and relaxing beneath blue skies.

Berchem was one of a second generation of Italianate landscape artists, which included such painters as Jan Both, Jan Asselijn, and Adam Pynacker. They all painted scenes

de Koninck: *Landscape Panorama.* 92·5 × 112cm, 1676

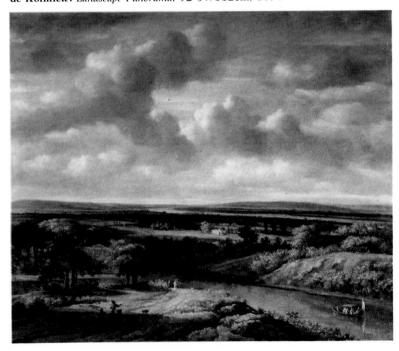

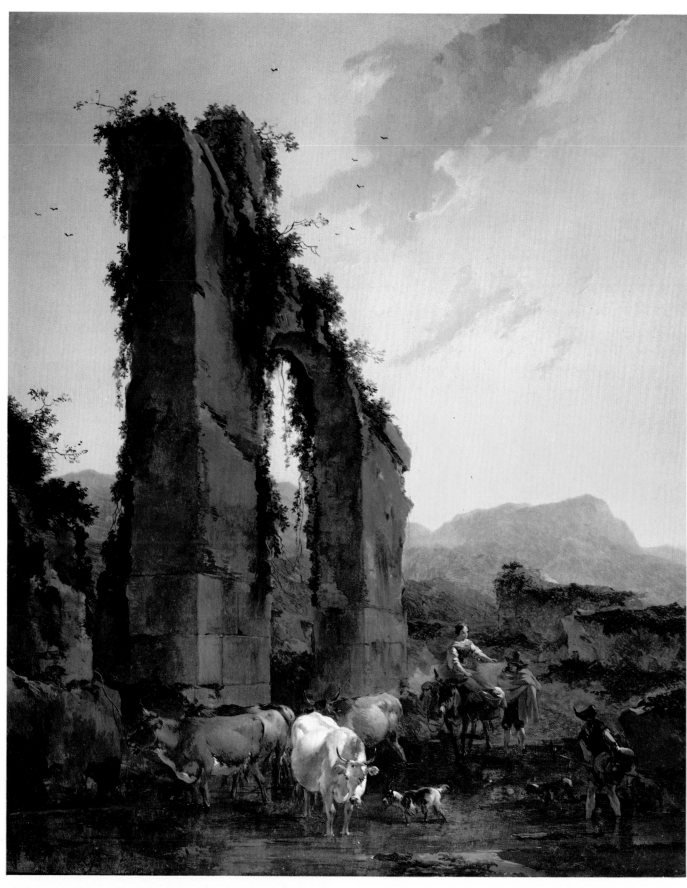

of the Roman countryside, where paths wind their way among ruins, and shepherds and their flocks bask in a golden haze. The influence of these painters extended to others who never even set foot in Italy. Aelbert Cuyp, for instance, was particularly indebted to the art of Jan Both, especially for the glowing, golden light which pervades his paintings of Dutch scenes. *Landscape with Rider, Shepherdess and Cows* is rather Italianate in feel. Cuyp was, however, more than a mere imitator: in the artistic isolation of Dordrecht, where he spent his entire life, he was able to develop his own personal style, the most notable feature of which is the use of cows as a compositional balance to distant views.

Opposite **Berchem:** *Peasants with Cattle by a Ruined Aqueduct,* 47 × 38·7cm, c.1658

The warm glow that pervades this picture, and the picturesque Roman ruin are characteristic of Nicolaes Berchem, who specialized in Italian pastoral scenes, where local colour in the shape of Italian peasants is set against decaying monuments. Stylistically, his work anticipates the Rococo, and the gay arcadian mood of Watteau, which is, perhaps, why his paintings found particular favour with eighteenth-century French collectors. The dating and exact location of this work are uncertain. Various suggestions as to the date have been made, varying from the late 1650s to the 1670s. Although Berchem visited the Roman campagna in the 1640s, and probably again in the 1650s, the painting was not necessarily executed in that area, and may just be a reminiscence of the artist's travels, completed on his return to Holland.

be the father of Dutch seascape, certainly have this aspect. They are usually portraits of fleets, or depictions of battles, and are full of narrative incident. It was Jan Porcellis, and his follower, Simon de Vlieger, who first started the move away from a seascape based on the minutely detailed depiction of ships towards a seascape concerned with atmosphere, sky and clouds. Both artists were instrumental in forming the style of the younger generation of sea specialists, such as Jan van de Cappelle, and Willem van de Velde.

Cuyp: *Landscape with a Rider, Shepherdess and Cows,* 135 × 201cm, c.1655–60

This is one of the best works of Cuyp's maturity and shows very clearly how Cuyp assimilated Italianate motifs into his repertoire and reworked them, investing them with a Dutch flavour. The mountains and landscape background to this painting could have come straight out of a work by Both or Berchem, yet the shepherdess has a solidly Dutch air about her which belies her Italian origins. Many of Cuyp's paintings are masterpieces of classic composition and reflected the general trend towards a more structured form of landscape painting, which developed in Holland after the middle of the seventeenth century. Here, the eye is gently led through the canvas by a series of curves; starting with the distant landscape, we follow the line of the river bank via the buildings, the flock of sheep to the cows, and eventually arrive at the man hiding in the foreground. There is a faint glimmer of golden light on the horizon, which adds to the feeling that we are in a pastoral paradise.

Cuyp also made the occasional excursion into painting seascapes and rivers, where he concentrated upon a rendering of atmospheric effects. Paintings of the sea had a special importance in seventeenth-century Holland, where so much was based on trade and shipping. It is impossible to find a picture of the sea where there is not some evidence of this commercial activity in the shape of sailing vessels. Early seascapes tend, like winter landscapes, to show stylistic affinities with Flemish painting, showing hordes of small, finely painted ships being tossed around in the waves, viewed from a high vantage point. The works of Cornelis Vroom, said to

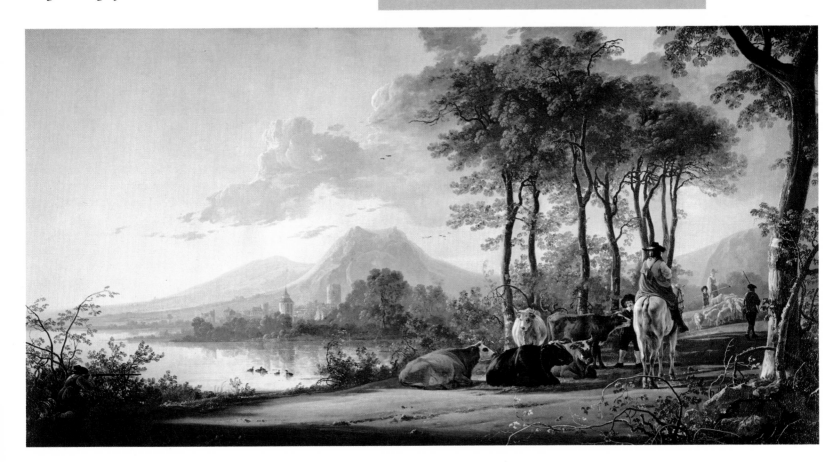

van de Cappelle: *The State Barge Saluted by the Fleet*, 64 × 92·5cm, 1650

Jan van de Cappelle was a native of Amsterdam, and evidently a self-taught, part-time painter. He was active in his father's dye works, and a great collector of other artists' seascapes, and his own paintings are rather rare. His works demonstrate a search for classical formal perfection, with horizontal and vertical elements balanced to create an exquisite sense of calm. Few of his paintings show a wide expanse of sea. They are mostly ports where ships lie at anchor, or at the mouths of rivers. *The State Barge Saluted by the Fleet* has the gay, festive mood of a pageant, and is a good example of van de Cappelle's concern with reflections in calm water, cloud formations, and clear colours.

Willem van de Velde's *Cannon Shot* treats a similar subject, but in a more sombre, grandiose manner. The work belongs to the first half of van de Velde's career, and reflects both his patient observation of weather and the trend in Dutch landscape in the middle of the century towards a classicism based on renewed emphasis of pictorial structure. Van de Velde was a most versatile artist, and was capable of depicting both ships in storm, and calm port scenes. In 1672 he moved to England with his father, also a marine artist, and produced a large number of works which still hang in English country houses. He was widely admired in England, and had many imitators, whose work has often been confused with his. This may well account for the tendency of art historians to lament his apparent decline in later life.

Just as there is something characteristically Dutch about the seascape, so still life is a genre that is primarily associated with Holland. Still life is an outgrowth of the Dutchman's desire to record the domestic world about him. There was no general term to describe still life painting until the word *stilleven* came into use around 1650. Before this date, still

van de Cappelle: *Effect of Water in a Port*, 55 × 70cm, 1649

van de Velde the Younger: *Cannon Shot,*
78·5 × 67cm, c.1670

Willem van de Velde was a great master of atmo-
spheric effects, for which he was highly esteemed by
future generations of landscape artists. He spent half
his life in England, and his effect on English painting
was considerable: Turner was a particular admirer of
the naturalism of van de Velde's work. *Cannon Shot* is
one of his greatest paintings for its juxtaposition of the
calm sea and the sky filled with billowing smoke,

shot is not a battle signal, but a salute of friendship.
The vast ship seems to be lowering her sails, and the
details of the rigging are faithfully observed by the
artist, who had a very accurate knowledge of their
anatomy born from his numerous drawings of individual
ships. This work was intended as a pair to *Ship in a
Storm*, also in the Rijksmuseum. The tempestuous
composition of this latter work, which shows a similar
vessel lurching in powerful waves against a back-
ground of storm clouds, makes an excellent contrast
to the serenity of *Cannon Shot*.

Dutch Painting: **Bollongier**

Heda: *Still Life with Blackberry Pie,* 54 × 82cm, 1631

This work exemplifies Willem Claesz. Heda's mature style, and shows the monochromatic breakfast piece at the height of its perfection. The subtlety of the composition rests on the delicate use of tone and texture, and the ease with which the eye is led back into space along a series of diagonal lines. The table is covered by a dark green cloth over which is laid a linen napkin. The greenish tinge is echoed in the half-filled glass, and in the background. Unlike banquet scenes, which usually contain an element of pleasant anticipation, this is a scene of disarray and aftermath, with an upturned bowl and a broken glass. The watch in the foreground acts as an ever present reminder of the passing of time.

life paintings were labelled according to their contents, such as 'breakfasts', 'banquets', 'fruit pieces'. There was a definite code concerning which objects belonged in each category; items that one finds in *vanitas* still life works would not occur in breakfast pieces. The earliest still lifes were mainly of fruit and flowers, reflecting the immense importance to the Dutch of flower growing. Following the pattern we have observed in the development of landscape, the earliest painters were all Flemish in origin. Ambrosius Bosschaert the Elder, Balthasar van der Ast, and Roelandt Savery were responsible for bringing the still life ot Holland. Their works tend to show

neat, symmetrical arrangements of painstakingly delineated flowers which do not overlap, and which are seen from a high viewpoint. Hans Bollongier's colourful *Bouquet of Flowers* belongs to this tradition. Bollongier was actually the only flower painter working in Haarlem, which is ironic, since it was a major flower-growing district.

Pictures of food, or breakfast pieces, developed at the same time as flower paintings, and also tended to show objects placed on a table, fitted together like jigsaw pieces. The early breakfast paintings were international in character, but after about 1620 the Dutch began to make their own unique

Pieter Claesz: *Still Life,* 39·5 × 60·8cm

contribution to the genre in the development of a monochromatic style of still life which corresponds to that of tonal tonal landscape. Pieter Claesz. and Willem Claesz. Heda, who both painted at Haarlem, are representatives of this trend in still life. Pieter Claesz.' *Still Life* at Prague and Willem Claesz. Heda's *Still Life* at Dresden both show a concern with establishing the simple relationships of one object to another, and with unifying the entire painting through tone. The contents of their paintings are relatively humble; bread, cheese, pewter jugs, glasses, and rumpled table cloths all form a mundane contrast to more flamboyant flower paintings. The keynote is simplicity, rather than excess.

The monochromatic approach to still life was superseded in the middle of the century by a return to a more colourful, elaborate type of painting, the banquet piece. Jan Jansz. van de Velde's *Still Life* hovers somewhere between the two styles, but Abraham van Beyeren's work, and canvases by Willem Kalf both belong to the newer, more ostentatious way of painting. The frugality of the previous generation, which had fought wars of independence from Spain, had given way to a more luxurious way of life, which made itself felt in these showy works.

The last category of still life which should be mentioned is the *vanitas* painting, where objects symbolic of mortality, such as skulls, instruments of time, soap bubbles, and roses, are heaped together with items denoting worldly pursuits, such as books, or musical instruments. They are a very obvious form of *memento mori*. Yet there is a sense in which all still life, indeed all depictions of the natural world, are emblematic of change and decay. There is a paradox at the centre of Dutch seventeenth-century painting: while the art of the period is dominated by a quest for natural appearances, there is an inescapable sense of death in life.

Jan Jansz. van de Velde: *Still Life,* 64 × 59 cm, 1647

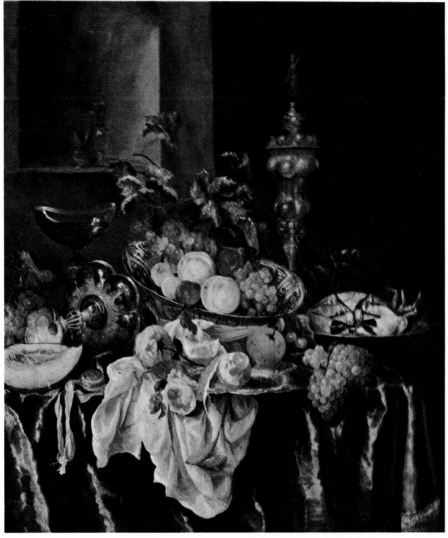

van Beyeren: *Still Life,* 126 × 106cm

Kalf: *Still Life*, 71·5 × 62cm

This still life is a show of virtuosity, despite the relatively simple organization of the objects on the table. Each piece is picked out from the rest, given its full weight in the composition, and illuminated by a soft light that emphasizes the texture of the fruit, bowl, glass, and jug. The objects seem to glow against the rich, dark background. The still lives of Willem Kalf belong to a later generation than those of Heda. The humble components of the breakfast piece gave way, later in the century to displays of wealth in the 'pronkstilleven' (still life of ostentation), of which this is one example. In these luxurious paintings, vessels of gold and silver, expensive glass goblets, rare fruits, exotic foods and Chinese porcelain are shown in abundance. They are far from being the objects of everyday life that one finds in earlier paintings. Kalf was born in Rotterdam, and spent four years in Paris before returning to Amsterdam in 1653. Amsterdam, as the affluent city, was the natural centre for this type of painting.

List of Illustrations

Bibliography

FUCHS, E. H.: *Dutch Painting*, 1978
ROSENBERG, J.: *Rembrandt*, 1964
ROSENBERG, J., SLIVE, S. and TER KUILE, E. H.: *Dutch Art and Architecture 1600–1800*, 1966
SLIVE, S.: *Frans Hals* 3 volumes, 1970–74
STECHOW, W.: *Dutch Landscape Painting of the Seventeenth Century*, 1966
WRIGHT, C.: *Vermeer*, 1976